Concert for Buchenwald

R E B E C C A H O R N

The colonies
of bees undermining
the moles'
subversive effort
through time

Concert
for Buchenwald

Part 1
Tram Depot

Part 2
Schloss Ettersburg

Scalo Zurich – Berlin – New York

The colonies of bees undermining
the moles' subversive effort through time

Concert for Buchenwald
Part 1: Tram Depot
Part 2: Schloss Ettersburg

Installations by Rebecca Horn
15 May – 15 October 1999

Content

Preface

It was not for an exhibition, but for a specific place, for a town still bearing the brunt of its history, that Rebecca Horn devised her installation in Weimar. She described this work in a poem, *The colonies of bees undermining the moles' subversive effort through time,* to which she gave expression in two connected, but spatially separated installations, one in the White Salon in Schloss Ettersburg, the other in the tram depot located in the centre of Weimar. She gave the two pieces the joint title *Concert for Buchenwald.*

Down in the town centre Rebecca Horn formulates the abdication of civilization as a notice of its loss. Sixty years earlier, its 'citizens saw the work, the name and the dignity of Goethe deeply stained by the construction of the concentration camp on the hill'; these were the words used at the time by the Goethe Society in a commemorative address directed at the perpetrators.

The site chosen by the artist for the complementary piece, a more luminous, though by no means unbroken work, was the White Salon in the castle on top of the hill that overshadows Weimar.

It has been a constant principle and purpose of the Kulturstadt Weimar Foundation to draw attention to neglected sites in the town, so as to establish a dialogue between the town's history and innovative, contemporary work created by artists. Rebecca Horn has embraced this dialogue and through her art transformed it into a sculptural event.

The idea of using of these two particular sites began to take shape in her mind little more than one and a half years ago. She has now charted her course, setting her marks in ashes in one place, and in glowing light in the other.

The artist made this piece specifially for Weimar. It cannot be transferred, nor can it be severed from where it is located. The spaces and the works are mutually dependent and remain inseparably en- twined. Rebecca Horn's activity has become intrinsically embedded in the soil of this town's history, and the work she created has cut to the very quick of Weimar's identity, bearing a relevance as manifest as it is unambiguous.

Inside the tram depot of a disused power plant we encounter walls of heaped layers of ash, the ash of destruction, and find a skip truck taken from Buchenwald that, like Charon's boat, ferries back and forth, unable to come to a rest in spite of the barrier wall. Musical intruments are piled high, all wrecked, lost and abandoned. Violins, mandolins and guitars have fallen silent, as have the people who once made them resound with music. A flickering light emerges after the truck's collision with the wall and begins its tentative, hesitant ascent like a soul departing from the body.

In the White Salon of Schloss Ettersburg there are gyrating, rotating mirrors, accompanied by the frenzied hum of bees, their luminously hovering hives, the sound of two bowed notes drawn across an upright cello. A rod, like a conductor's baton, writes figures against the rising landscape that was once also a backdrop to the terror. Wandering light flashes in the mirrors that have been shattered by the falling stone like a 'memento mori of ideas'.

With these two works released from time, indeed timeless, Rebecca Horn closes the circle in Weimar. Things are brought together to coincide; episodes of happiness and of horror from different se- quences of time now figure concurrently in the present.

In a highly personal manner, I associate her work with Jorge Semprún's *Pallid Mother, Tender Sister,* an oratorio he wrote for Weimar several years ago. And I am also reminded of the conversation that

Léon Blum, the former president of France, later a concentration camp prisoner and the author of *New Conversations between Goethe and Eckermann,* held in this stage play with 'his' Goethe. I am reminded in particular of one utterance Léon Blum makes to Goethe: 'There is a need for dreams. What we have experienced so far was a caricature.' The real caricature of evil and the end has taken shape inside the tram depot, while up on the Ettersberg Hill the dream is reflected in gyrating mirrors.

With her walls of layered ash in the depot, Rebecca Horn draws a cloak of fear and despair close around our shoulders On the hill she leads the way out of the darkness, indicating a realm of other possibilities that find increasingly reduced space in our lacklustre daily lives. Her work does not offer the kind of pleasurable entertainment we might, as others would say, look forward to visiting; it is not an aesthetic gesture designed to flatter a town or a region with all the accompanying talk of rediscovered identity.

Here we witness an artist who has got down to work, without consideration for the impression it will make; here is an artist creating images of tangible immediacy which have been culled from the depths of her own experience. Rebecca Horn's work simultaneously embodies lamentation and hope, an aesthetic text of death and life filled with suffering.

In a large city somewhere in Germany, now restored to the nation's capital, a heated controversy surrounding a memorial and the purportedly correct form of remembrance has dragged on for the last ten years. In a small town somewhere in Germany, a town free neither of burden nor inculpation, something was quietly and unassumingly made that evinces such clarity, justification and cogent logic, that its creation required neither drawn-out discussions nor compromises.

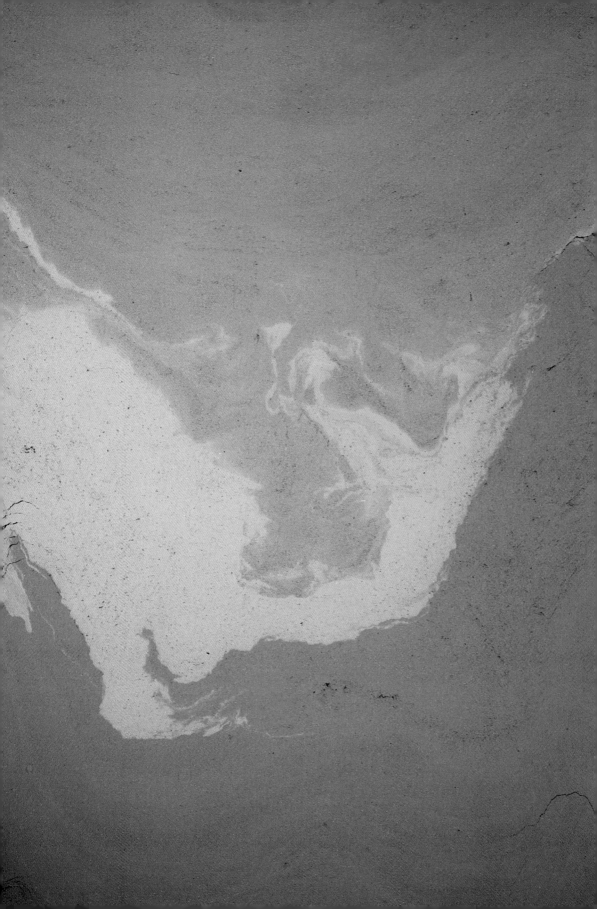

Concert for Buchenwald

Close to Naples, in the area of the Campi Flegrei, where the earth never seems to rest, there is a beautiful stretch of tranquil water surrounded by Roman ruins, reminiscent of a painting by Claude Lorrain. It is Lake Avernus. Its name derives from the Greek word *aornos,* meaning 'without birds'. It is thought that at this spot sulphurous fumes once used to seep out from the cracks in the earth, making it intolerable for the birds to remain there. In antiquity this round lake bereft of birds was felt to be a strange and eerie place, a veritable *locus terribilis,* terrifying and awe-inspiring. Here, people supposed, lay the entrance to the Underworld.

Rebecca Horn first visited the former Buchenwald concentration camp in September one and a half years ago while still deliberating what kind of project she might do in Weimar. She describes the unique site of the barren, stony field on the crest of the hill as bald, smooth and round as a gigantic skull. She speaks of the wall of beech trees all around, which here and there opens up offering generous vistas onto distant hills. That day not a single bird was singing, it was utterly quiet. But maybe this was just because it was already September. In May, however, the birds can be heard singing in the lush, verdant foliage of the beech trees as they must surely have done fifty or sixty years ago. And yet the broad, bare field on the Ettersberg was once an entrance to the Underworld. Where many countries had dreamt of building paradise on earth, this century has instead witnessed the creation of hell, of many hells on earth.

I sense within me a distaste for my own associations. What does the grey misery of Buchenwald, the thousandfold human desecration, have to do with Lake Avernus and the tumbledown tiled domes lining its shores? How dare I combine images of classical beauty and serenity with mass torture and mass murder? We have lost that ability of previous ages to elevate pain to a

higher state where, behind the grimace of death, some indestructible quality is made visible. To our ears now, the dignity of the 'dying Gaul' must surely ring like a palliative euphemism for mere wretched death on the battlefield, while spiritualized crucifixions are read as torture made aesthetically palatable in the service of religious propaganda.

It is not deeper insight that has taught us this perspective on things, this only ostensibly naked outlook. What distinguishes the great epochs of history is rather the hue of the tinted glasses through which contemporaries have always perceived things and events. An invisible hand places differently tinted spectacles over the eyes of each coming generation, rendering invisible what their predecessors once saw, and revealing all that had hitherto been concealed.

What does a human being cost? In the past, reference books for young people used to list the materials that went into making a human being: calcium, water, protein, other substances — all quite cheap and costing about 40 marks. In those days organic chemistry was not sufficiently advanced to work out the value of the constituent organic compounds inside the human body. Recent findings reveal that each individual is worth about two million marks — but can we be certain that the pace of scientific progress will not reduce this price again? Such considerations might sound cynical. When it comes to fundamental considerations we are bizarrely split, but this split is no accident, it stems from the nature and origins of our thinking. Human rights are the last remaining moral yardstick in our current world, in the name of which we even feel justified to wage war, analogous to the crusades fought in the Middle Ages. Human rights were formulated by 18th-century philosophers convinced that man was a machine without a soul, a clockwork mechanism which will run as long as it is wound up. Yet the prophets of human rights were also repudiators of free will. The autonomy of each individual was advocated by thinkers who paradoxically held a determinist view of each man's fate. And another, now far more advanced science not only denies the notion of free will, but even casts doubts on consciousness as an expression of the individual. Sometimes one might even conclude that the human being, the subject of the very human rights still considered universal-

ly valid, had ceased to exist. But then, from the middle of some sphere we have long since given up trying to define, an alien force reaches out and grasps us by the throat — our hearts grow heavy when we are made to witness human lives being crushed.

Numerous issues could arise from such considerations, but I will not formulate them, since Rebecca Horn's art would not offer any answers. Art does not serve to answer questions. In its treatment of reality it engages in a phenomenon in which every person is an artist: the act of dreaming. Dreams respond to all the pressing events of the previous day, without actually resolving, analyzing or explaining them. But there is nonetheless something that a real dream unveils; it illuminates the nature of the true enigma that managed to remain concealed beneath the flood of daytime events. The dream's method is to collect fragments of the day's experience and assemble them in a new and somehow surprisingly accurate order.

For her project in the Weimar tram depot, Rebecca Horn also began by collecting. In and around the villages of the Odenwald forest surrounding her studio she spent a year collecting ash. Ash from paper, which is very pale and bluish, ash from wood which, depending on the tree, is greenish, sand-coloured or light grey. Grind or pulverize this ash and it is reduced to fine powdery dust that betrays no sign of having once been the basic substance constituting a living object. For our sensual perception, powdered ash represents materiality in its highest degree of abstraction. A heavy log of wood changes into a small heap that can be blown away with a gust of air. The extent of concentration and distillation is evinced by the small tins that hold the remains of a human being after cremation. A skeleton is almost like a caricature of life. Ash does not even represent death, it is a very close approximation of oblivion.

Inside the Weimar tram depot are two high, long walls of glass facing each other. Behind each of these glass walls Rebecca Horn strewed the collected ashes as they were delivered to her. Piled layer upon layer, the contrasts rendered the ash's colour visible again. Behind the glass, waves, marbled contours and xenoliths like those found in geological formations gradually built up. Coloured clouds emerged, as if the ash in its fixed state

were now trying to simulate the billowing smoke which accompanied its creation. In the desert winds blow across the dunes, arranging them into waves of parallel lines. The winds of history blow over the millions, combing individual lives into patterns which are only visible from a great distance in time. Behind the glass walls, however, all movement has been brought to a standstill. Here, the fleeting dust of virtual nonexistence has been returned to something extremely solid. The ash has been baked into a kind of lightweight stone; blocks formed from the condensed ash are shot through with fissures like cracked rock, and along some fractures they show signs of crumbling. Were one to excavate a big field of ash, this is what the shaft walls would look like. We are familiar with the enormous marble ossuary vaults at Verdun and Douaumont, and in Italy's cemeteries. What would come to light if one raised the marble curtain with all its bronze plaques, gilt palmettes and names, whose syllables give such a vivid sense of a human being? But inside the tram depot there are no marble walls. There is nothing repellent about the sight they might have obscured. Beautiful stone spreads out behind the glass — abstract, cool and mute.

Yet the hall itself is not mute. It is filled with the nerve-grinding noise of machinery. A wagon travels back and forth along a single track, a small mining or stone quarry truck which cannot stop moving, even without a load. With a crash it hurtles against the old black-painted wall of the tram depot, yet this obstacle does not bring it to a standstill and the small truck soon starts rolling back. At the other end it is stopped again. Here, piled up on the track are old violins and guitars wedged into each other, rammed one inside the other, with snapped strings, smashed and splintered soundboards, lost pegs and contorted necks. The bodies of the violins and the guitars are lying in rows stacked over and under each other. Shabby fiddles made of cheap pale wood lie haphazardly side by side with wonderful tortoise-shell speckled, exquisitely aged instruments. Guitars once played by Gypsies to accompany their songs, *O sole mio* mandolins inlaid with mother-of-pearl, lutes with turtle-shaped bodies crafted for Elizabethan love ballads and delicate violins that once performed Beethoven's late quartets — an entire nation of musical instruments in all its vulgar and privileged aspects brutally shoved

together and transformed into rubbish. Stringed instruments have human forms, something artists observed long ago when they put broken lutes in the company of skulls in their paintings meditating on *vanitas.* Violins and guitars have waists and curvaceous bodies, and they have voices which, at least in the case of the violin's deeper registers, resemble the human voice. On seeing them, even in a broken state, one cannot forget that voice. It is incorporeal, immaterial — when a violin's material value is calculated its voice is never included. Yet it is precisely and solely its voice that determines this instrument's value.

Immaterial though the precious voice is, when one is standing in Rebecca Horn's depot it is as if the voice, the many hundred voices belonging to the demolished, shattered instruments, were being loaded onto the iron wagons, as if this truck like a bargeman were collecting the voices of the dead violins and ferrying them over to another shore. Over there everything is walled up—there is no such thing as the 'beyond' on the same level. So now, with their unbroken energy the voices are seeking their own way. In restrained explosions, in flashes of lightning similar to wandering will-o'-the-wisps, they climb upwards. A transport, the end of a transport, a wall, a transformation, a flight, an escape through the air, a blinding glare and a disappearance.

Lodged in the White Salon inside Schloss Ettersburg is the other end of the imaginary arc Rebecca Horn has spanned over Ettersberg Hill and the Buchenwald Camp. This castle is an Italian fantasy built in a German valley, a landscape of elected affinities, overgrown and decaying, and thus probably has more affinity to the great Weimar era than to the excessively restored Schloss. This is the castle where Goethe first staged his *Iphigenie,* an amateur performance, in which he himself played the part of Orestes. The major theme in two of his classical dramas is the onset of madness, and in each case he closely associates this madness with himself: Torquato Tasso's paranoia, the conspiratorial obsessions of the highly privileged yet exploited poet, and the madness inhabiting Orestes who is hounded by the Furies — madness as the result of inordinate, irredeemable guilt. In Sartre, the Furies in pursuit of the matricide have turned into a swarm of flies. The restless

swell and ebb of humming that fills the White Salon today, where over two hundred years earlier Orestes struggled with his despair, is produced by bees. Bees, if provoked, may be dangerous, but they are not destructive. They create something quite awe-inspiring, an intelligent collective, a harmonious society — and produce exquisite substances: wax and honey. With earnest and imperturbable fervour they devote themselves to their gradual, constructive labour. The thousand fine knives of their intensity repeatedly slice through the fog of depression. The place where they work is not an intact, pure world. Here stones sail through the air and demolish glasshouses and daydreams. Every so often a lump of basalt comes plummeting down from the decaying ceiling laced with the rotten crowns of Weimar princes, crashing onto the mirror which reflects the light from the beehives, shattering the glass. The light is scattered and the mirror shards scintillate like the agitated surface of water.

The bees are captives within the White Salon, while the view from the neighbouring room opens out onto the romantic tableau of a hilly landscape that floods the eyes with green. Here there is a cello playing itself with two bow arms, a magical sixth interval that weaves itself into the humming of the bees and the hissing rush of the falling stone. Like a conductor's baton, the calibrating needle of a Chinese scales is inscribing a flourish, various lines or maybe even several words onto the green hill outside. Writing in air is a perplexing endeavour. At first you feel you can read it, but then the phrase keeps slipping away. In return, the phrase is continually rewritten with endless patience, prompting the viewer to continue deciphering it.

Death in Buchenwald was the result of wrong, but this wrong now lies in the past and has been judged. Yet death, madness and despair still threaten each one of us, accompanying our lives until death finally gains the upper hand. It is only against this background that all sounds and noises, all colours, forms and movements can develop their hyper-real, oppressive proximity, as if they were trying to absorb and preserve the entire living world.

Translated by Matthew Partridge

Concert for Buchenwald, Part 1: Tram Depot, Weimar

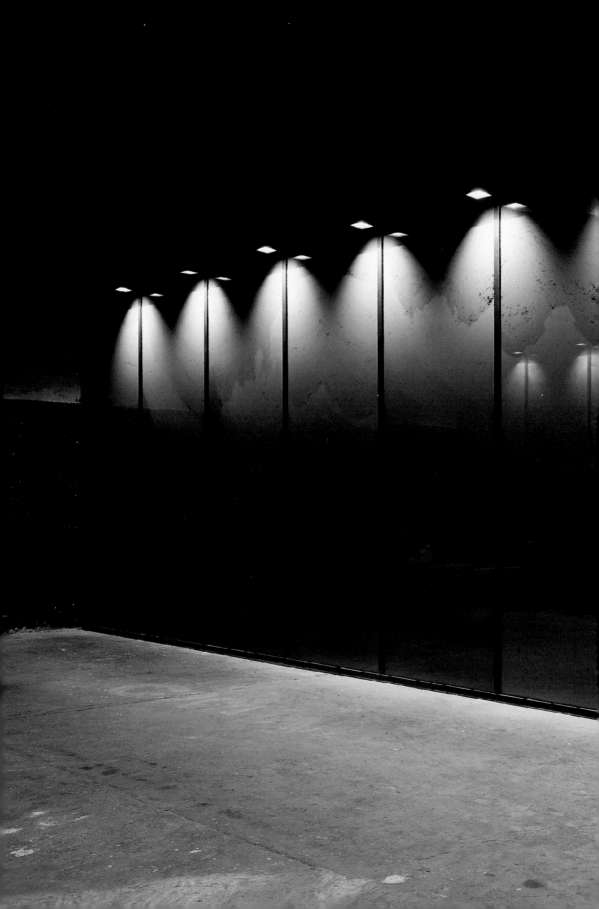

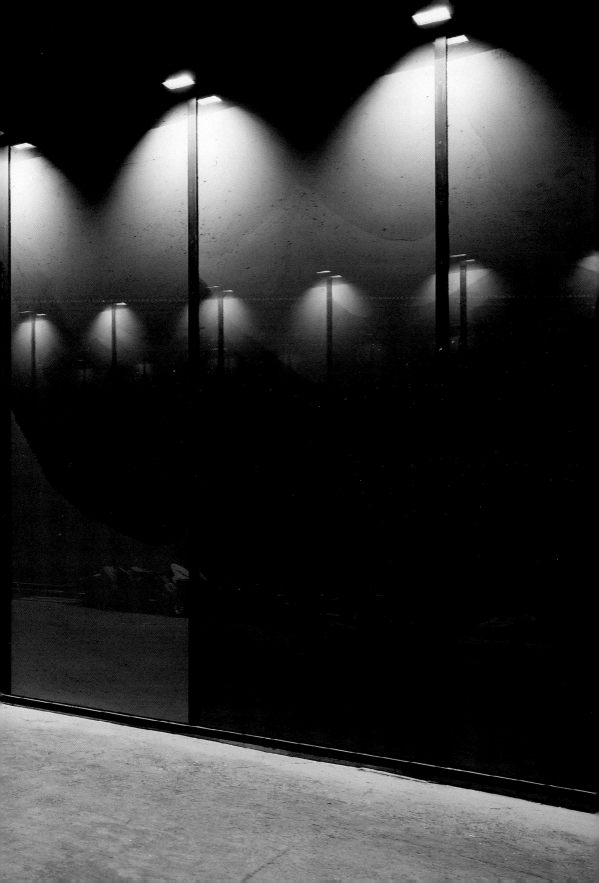

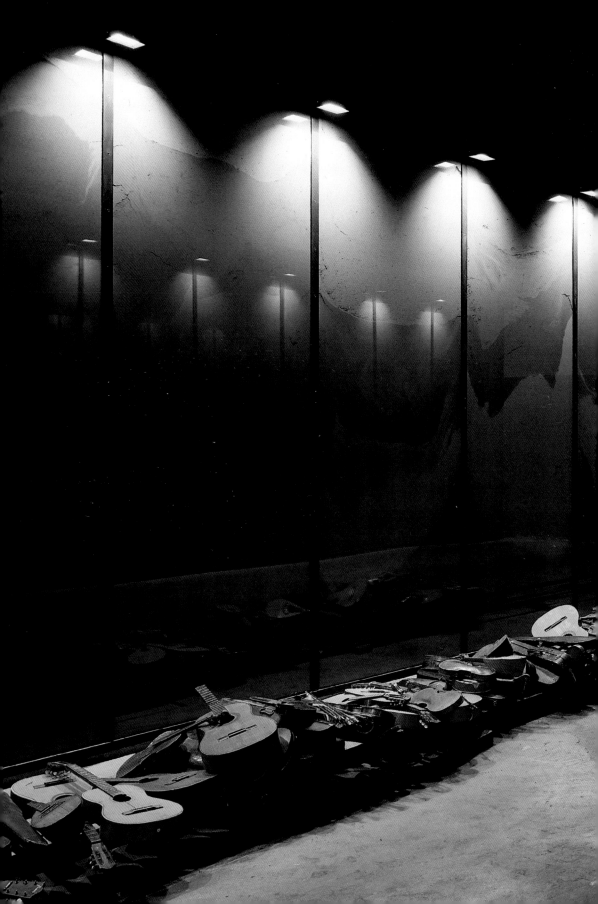

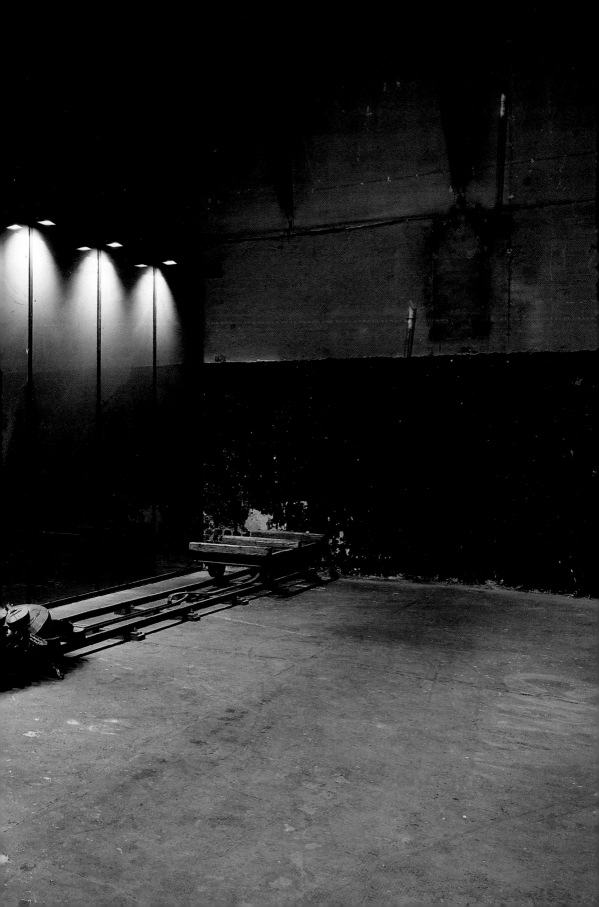

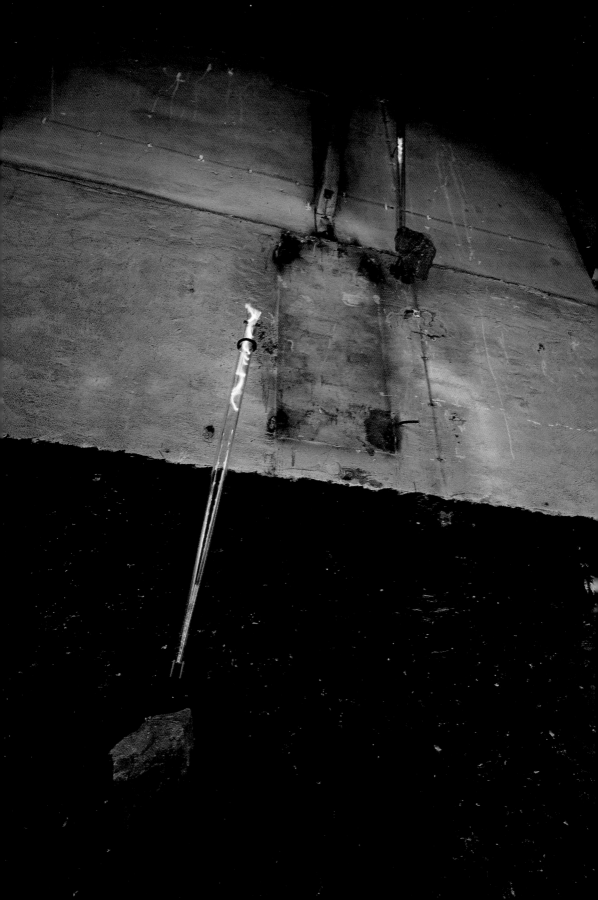

The colonies of bees undermining the moles' subversive effort through time

Notebook, 27 September 1997 – 15 May 1999

Buchenwald

shaven dome of a skull

the cerebral execution machine camouflaged inside a height scale

neck bone oracle

no birds upon the hill, no sound

the dead are joined in fear

forming a leaden skin belljar suspended over Weimar

even trees refuse to grow here

the energy absorbed from inside the earth

weighing down with stones the camp's perimeter.

In Poland prisoners were given an axe

sent into the woods to fell a tree

standing upright each had to embrace his tree

from behind they all were shot.

A forest cleared of bodies and trees.

The sun drew bodies and plants in flames

into ashfields of a charred landscape.

Eruption from the dead earth's crust
darkness, heaviness down inside
descending each and every day.
Blind movements with relentless stamina
molehills, volcanoes
secret satellite stations
moles sending their knocking signals from inside the earth.

The room of books
flowing wax welds the books together
burning them down.
To build a library of ashes.

Street tram depot in Weimar
landscape of the 56,000
laying the tracks through the gate into the interior
a small transport waggon from Buchenwald
moves to the rhythm of the heart against the rear wall
the collision generates electric sparks like soul threads climbing up
to Illuminate the ashen landscape.

Les funérailles des instruments

The violins, bodies, are still sleeping on the tracks
waiting patiently for their transport of salvation.
The truck runs over a violin's neck:
crushed, it quietly emits a sound.

Devour the cactus of the void

Span an arch from Schloss Ettersburg over Buchenwald.
The bees have lost their centre
they swarm in dense clouds high above
their radiant beehives are deserted.

Wandering islands of light seek the lost ones
casting an axis of escape
to catch them up in fleeing motion
shaping a planetary map of light anew.

The beehives, the wandering light of colonies
the attempt to flee destruction
at the mercy of alchemistic processes:
mirror of water, heated by cayenne pepper, turns to blood
evaporates over fire into glowing light.

Light alters the island poles of the bee swarms
one of the colonies will always be destroyed
eternally wandering and searching,
writing signs in dark water
the wind inscribes in sand,
changing the signs.

Labyrinths of moles
with their ramified streams of energy they resemble
the flight paths of the bees.
They meet in human beings
as a catalyst
connecting the above and below of the mind.
Through the process of transformation
cautiously writing the language of new signs.

Samson killed a young roaring lion.
Inside its body he found a swarm of bees and honey.
Releasing the bees, he bore the honey in his hands,
eating and walking, he betrayed his secret to no one.

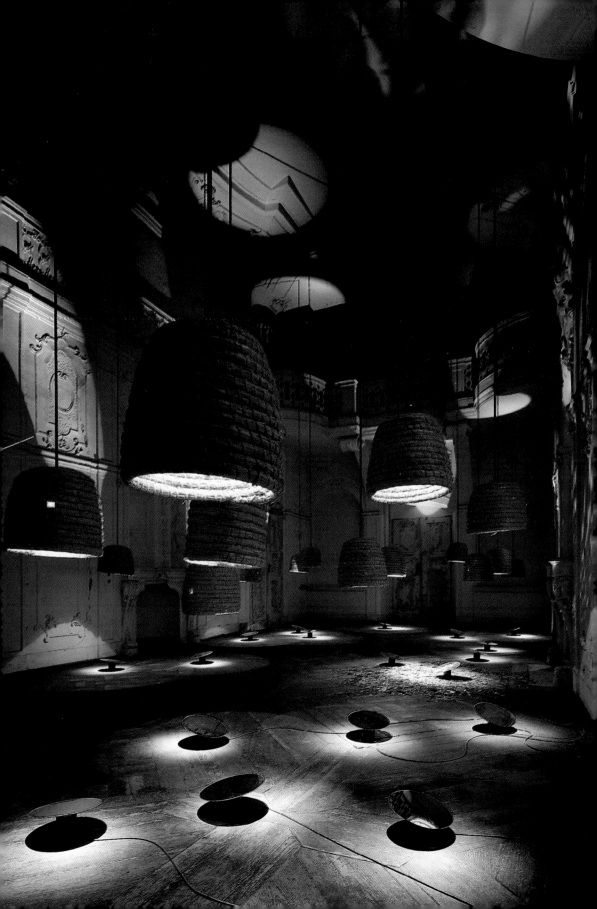

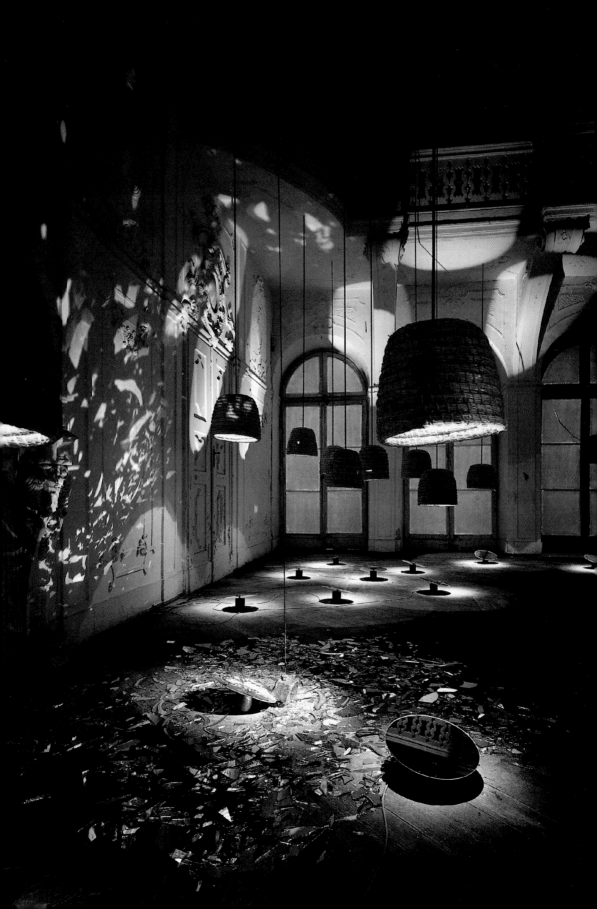

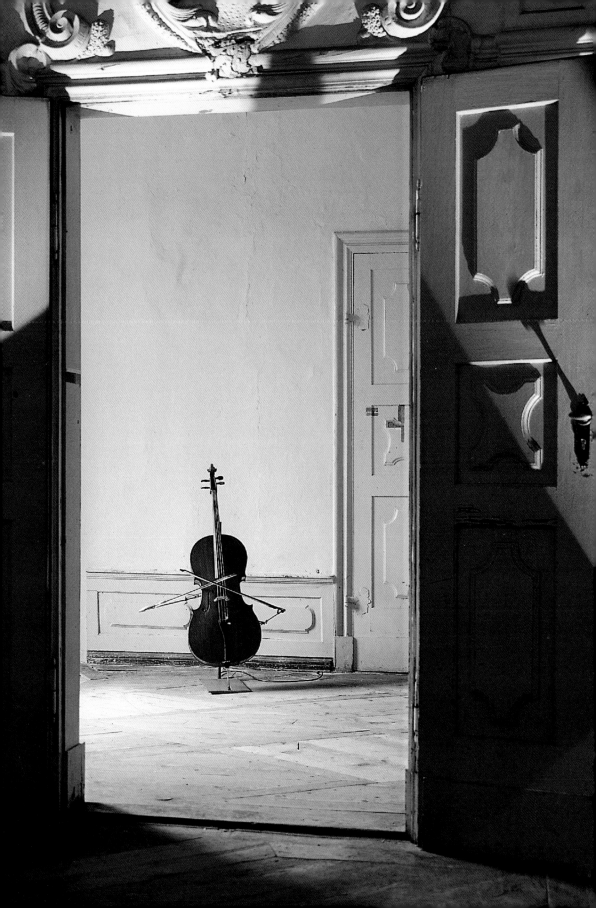

View towards Buchenwald, Schloss Ettersburg, Weimar

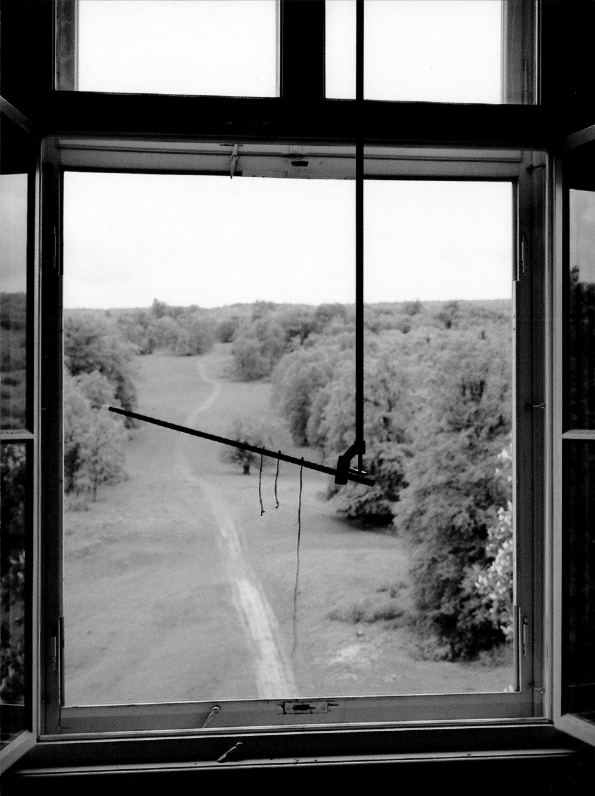

The Archive of Ashes

The generally acknowledged purpose of every archive is to store evidence of the past and preserve it from destruction, fire and eradication. The archive which most successfully fulfils this purpose is one which offers the greatest immunity against the destructive forces of time. The archive of ashes clearly comes closest to this ideal of indestructibility. Ashes cannot be destroyed, burnt or eradicated any further, they can only be dispersed. But even in a dispersed state, the archive of ashes still retains its virtual unity — as an opportunity for a new collection. Rebecca Horn's installation, *Concert for Buchenwald,* primarily represents such an archive of collected ashes. The ashes are stored in large cabinets which encase the room and are particularly reminiscent of the bookcases found in old libraries, where the books kept behind glass serve as the architectural consummation of the room, as well as its embellishment. Just as one's first response on entering such old libraries is the visual attraction to the pattern of colour composed by the books on display, once inside Rebecca Horn's installation one becomes immediately aware that the ash stored inside the cabinets consists of various colours — thereby creating an altogether engaging aesthetic effect. And similar again to old libraries, the strict geometry of the cabinets and the cold, uninviting surface of the glass walls set a particulary sublime and awe-inspiring mood in the installation. At the same time, one's first impression of the ash is not one of an unstructured, fluid, transitory mass, but of something which is compact and fossilized — of a massive block or a stone monument. What this represents is an archival collation of ashes which have been drawn from their scattered state, their diaspora, and transported to a place where they can once again constitute a self-contained, cohesive form.

However, this new monumental form that the ashes gain from having been collected and archived, bears no discernable or mimetic relation to the

things that were once burnt to produce them. Ash preserves no visual memory of the burnt objects or organic bodies — as opposed to the 'natural' process of decay and decomposition, which throughout all stages of trans-formation, deformation, reduction and dissolution always retains some mi-metic affinity to the original form. The cremation of a thing or a body also incurs a radical shift into a non-mimetic, abstract and non-objective condi-tion. In the custom of keeping the ashes of a cremated human body in an urn, the marked artificial and conventional character of the urn's traditional, classicist form further accentuates the radical break with the original form of the human body. In her installation Rebecca Horn draws attention to this radical loss of the original organic form by showing the ashes en bloc and replacing the classicist urn with rigorously geometric, minimalist forms, which point to a radical break with all mimetic endeavours performed by the 20th-century avant-garde by means of geometric abstraction.

Furthermore, not only have all mimetic similarities vanished from this archive of ashes, but so have all material vestiges of the individually incin-erated objects. The collected ashes constitute an undifferentiated mass in which the 'individual' ashes left over from the burning of specific objects can no longer be identified. The ashes intermingle. The boundaries separating individual bodies and objects disappear. With this diffusion of the bodies, all individual, qualifying and discrete features are dissolved — and are dis-persed. The distinction between the individual object and its surroundings ceases to determine this object's fate. The diffusion of all things in their ashen state instantly points to the most ancient — and most modern — of all utopian visions to have governed the political and artistic imagination of mankind over thousands of years. It is the issue of the individual's re-lease from his ontologically determined isolation, the entry into unified and integrated communion with universal totality. The ashes' cold collectivism clearly represents a far more successful fulfilment of this utopia than the much-vaunted ecstatic fraternities aspired to by living beings.

Certainly, there have been previous occasions where this form of post-romantic, but also post-mortal collectivism was treated both themat-

ically and aesthetically. Ernst Jünger, for instance, was fascinated by the sight of the mass of human corpses collectively decaying on the battlefields of the First World War — as opposed to the familiar process of individual decomposition that occurs down inside the grave: 'All secrets of the grave were exposed with a gruesomeness, in the face of which even the wildest dreams paled.'[1] The communal process of decomposition on the battlefield united all those who in life had inevitably been separated. This collectivism of death brought on by war was later described by Roger Caillois — with reference to Ernst Jünger — as a celebration which destroyed the old world of divisions, restrictions and isolation and, through the experience of such a radical release from the constraints of the self, made way for a new and vigorous era.[2] Hence the collective decomposition of corpses celebrated by Jünger and Caillois continues to be included in the general process of life. This is analogous to an old saying keenly reiterated in all arable societies which likens a decaying body to a seed that must be brought under the soil in order for new life to sprout forth from it. By contrast, however, the collected ashes primarily manifest their radical inorganicity. The ashes call to mind the Freudian death wish described in *Beyond the Pleasure Principle* — as a yearning to return to the mineral, inorganic and dispersed state preceding all forms of life, but primarily one that irrevocably extinguishes any form of individual life and denies the possiblility of all memory. Ash can be anything but agriculturally productive — and hence is everything but optimistic. It signals the resignation of any hope for reincarnation. Consequently, no phoenix can possibly rise from the collected, archived ashes, not even a collective phoenix, since these ashes derive from a fire that, far from being cosmic, is nothing more than a technically generated fire.[3]

The inexorable radicality of this work by Rebecca Horn is undeniably dictated by the installation's immediate proximity to Buchenwald — both through the explicit reference to the Holocaust and through the technologically organized cremation of human bodies that was a modus operandi of the Holocaust. Approaching the issues of the Holocaust in artistic terms has of course a long tradition. However, while this artistic exploration has

taken on a wide variety of forms and led to the creation of works of very different aesthetic and conceptual character, it can nonetheless be claimed that the great majority of these works reveals a common wish on the part of their artists to oppose the work of elimination and extinction brought on by the Holocaust with a work of remembrance and restoration. All reflection on the Holocaust is marked by numerous and varied endeavours to compensate and 'make good' the suffered loss, to excavate and stabilize the memory of the destroyed and buried past, and to retrospectively repair both the disrupted Jewish tradition and the lost heritage of a 'better' Germanness — and to resume this tradition with vigour. This explains why most artistic works which deal with the Holocaust include photographs, inscriptions or stones similar to gravestones, thereby raising hopes for some kind of eventual resurrection — all emblems of institutional remembrance. What we find are documents, pictures, texts, videos and film footage being amassed, we come across virtual synagogues being constructed on the internet, and witness museums and documentary centres being opened that simulate symbolic first-hand experience and offer palpable understanding of the destroyed past. In brief, an intensive search for vestiges of the past has been mounted.

Yet whatever view one might take of these numerous scientific and artistic efforts to restore the burnt past, it is evident in her exhibition that Rebecca Horn has adopted an entirely different approach. Her installation is without doubt also an archive, yet with the difference, as we have already seen, that it is an archive not of memory, but of oblivion — a collection of dispersed ashes, not specific ashes somehow located in the course of a purposeful search for traces, but simply some or other accidently found, random and radically scattered ashes. The aim of this archive is not to help us repair a historical rupture and bridge the gulf that separates us from those who have perished; quite the opposite, its purpose is to manifest the impossibility of establishing such a link between us and the burnt past. Compacted to stone, the ash that has been collected and exhibited here is an impediment to any labour of remembrance. Which is why it no longer

bears any relevance whose ash is on display and where it came from, for all the ash accumulated here acts as a wall irrevocably dividing us from the past. Any attempt to reinstate a link to the past is doomed to failure. The labour of memory must be abandoned at this point — it cannot proceed because all forms and traces that might direct us towards the past have been scattered. All the other elements of the two sections of the Weimar installation confirm and reinforce the impossibility of advancing further — they deny the continuation and stabilization of historical momentum. The truck tries to continue down the rails — but fails to make headway. The bees can be heard humming high above — yet they are unable to return to their hives. The inception of possible movement is enacted over and over again — but all attempts to further this momentum are constantly hampered and finally abandoned.

The immutable destruction of the historical past by means of fire has, incidentally, not entirely been a cause for regret in our culture, it has also been the object of celebration, on a par with the burning of bridges that, still intact, might otherwise offer a means of retreat and discourage us from advancing into the future. The fascination exerted by immutable, irreparable destruction certainly represents a significant thread of radical European progressivist thinking. Even Rousseau marvelled at the burning of the ancient library at Alexandria, a loss which was claimed to have opened up the way for a new school of writing. In particular, an affinity towards the irrevocable rupture with heritage is part of the psychological makeup of the radical artistic avant-garde, a tradition of thinking which has also informed the work of Rebecca Horn. This image of the irreversible loss of the past is well illustrated by a short text written by Malevich in 1919, *About the Museum,* in which the author considers the question of whether we should safeguard or destroy the vestiges of our past.[4]

After posing several rhetorical questions such as 'Do we need Rubens or the pyramids of Cheops? Does the pilot flying in the heights of our new awareness need the damaged Venus? Do we need plaster copies of ancient cities borne by Greek columns?', Malevich comes to the decisive conclu-

sion: 'Immediate life requires nothing more than what is part of it; and only that which grows on its shoulders is part of it'. What, incidentally, Malevich is alluding to here is by no means just a purely symbolic and aesthetic renunciation of the past in art. As he points out, 'life knows what it is doing, and if it decides to destroy something by force we should not try to intervene, since by preventing it we would be blocking the path to the new concept of life that is born within us. By burning a corpse we are left with one gram of ash, enabling thousands of graveyards to be fitted onto a chemist's shelf. We could make a concession to conservative forces by offering to cremate all past epochs, since anyway they are already dead, and then open up a pharmacy.... This would have the same effect, even if people examined the ashes of Rubens and his entire works — masses of ideas would germinate in them that would contain more life than his actual pictures (and take up less space).'

For Malevich, the ideas inspired in someone viewing the ashes of Rubens' pictures are certainly not recollections of the burned past, but are instead forward-looking ideas prompted by the realization that a return to the past has become impossible. The sight of the ashes obstructing the way back to our origins is meant to point us — indeed, even compel us — towards the future. Malevich happened to write this short text at a time when a widespread surge of enthusiasm for crematoriums took hold of left-wing, progressive circles. Cremation was viewed as a symbolic rejection of the church's promise of life after death, depicted in Christian mythology as resurrection from the grave. Anyone prepared to make room for the future necessarily had to consent to the cremation of his body and the scattering of his ashes. Many left-wing intellectuals, particularly Marxists, drew up their wills with this in mind. Above all, the choice between embalmment and cremation proved to be of political relevance. Stalin and Mao both instructed that they should be embalmed, while Trotsky and Deng favoured cremation. As it happens, belief in the promise of resurrection, provided the body is preserved (whether in an embalmed or a decomposing state), has ultimately turned out to be more than mere superstition. Advances in modern

38

genetics now offer the possibility of reconstructing the genetic code of even the most thoroughly decomposed corpse. Such research has recently been carried out, for instance, on the exhumed remains of the Russian Tsarist family, and on the remains of Thomas Jefferson. In future it is quite conceivable that cloning techniques will enable us to use the deciphered genetic codes of illustrious corpses to reconstruct living replicas of their bodies. On the other hand, as far as we can judge at present, cremation fully erases the genetic code, making it indeed utterly impossible to reproduce the past.

Hence, opting for cremation is synonymous with a radical repudiation of resuscitation, regardless of whether the choice is made for religious or scientific reasons. Such a rejection is lent further weight by the refusal to preserve old works of art or the historical memories of heroic deeds. Past works would be reduced to ashes, as would the bodies of their authors. In the eyes of radical modernism, with its (left-wing) Hegelian notions of historical progress as the labour of negation, cremating the past (which also comprises self-immolation) is the only service an individual can render unto history. This hygienic and highly industrial manner of dealing with the corpse also fascinated the public imagination in the 1910s and 1920s on a singularly aesthetic level. In the radically progressive mood that gripped Moscow during these years, artists and writers in particular were invited to take part in specially organized tours to experience the newly built crematoriums in operation—which also demonstrated in what order and manner the various parts of the body were cremated. These guided tours enjoyed great popularity, especially among avant-garde artists who were eager to take their friends and lovers with them to such displays. Highly typical in this respect were projects furthering the secondary use of heat emitted during the cremation of corpses, especially for heating public buildings. However, the grave inefficiency of Russian crematoriums at that time was cited as the reason why these projects were ultimately discarded — interestingly, it was generally believed that the best crematoriums and incineration specialists were to be found exclusively in Germany, and when it came to the business

of cremation, the Russians, and indeed the rest of Europe, were deemed to be lagging far behind the Germans.[5]

Such manifestations of ethical and aesthetic fervour for the workings of the crematorium are certainly difficult to envisage in the aftermath of the Holocaust. It has been remarked elsewhere that the avant-garde nurtured a specific form of anti-Semitism which viewed the Jews as the race that embodied the Old Testament, and consequently as an incarnation par excellence of the past.[6] There is even reason to claim that the margin between Old and New Testament also served as a paradigm for all demarcations between old and new drawn up thereafter in the course of European history, which has been so markedly conditioned by Christianity. As is well known, the Enlightenment also viewed itself as a departure into a new era and a kind of New Testament of reason that annulled all that had characterized the Old Testament — in the sense of a religiously transmitted legacy. It is no accident that various authors of the Enlightenment developed a singularly virulent strain of anti-Semitism — an anti-Semitic belief in innovation and renewal that was felt to be a radical rupture with tradition. Later on, this 'innovationist' anti-Semitism was to be found among many proponents of the progressive left, including Marx. To a similar degree this same anti-Semitism was also rife among numerous authors of the avant-garde, even in those who, unlike Céline and Ezra Pound, did not openly identify with it.

In many respects, the anti-Semitism of the Nazis also reflected this anti-Semitic quest for a new beginning — a new beginning which in its utter dismissal of the past also demands that the corpse of the past must be burnt. Familiar and influential both within avant-garde and Nazi circles, the theosophic doctrine that advocated the succession of cosmic epochs, attributed earlier origins to the Jews than, for instance, to the Aryan peoples. According to this theory, the great fire that was to signal the beginning of the new era of the Aryan race would axiomatically destroy all older races, and foremost the Jews. It is no coincidence that the elimination of the Jews is commonly termed 'Holocaust', a word which originally meant nothing other than an immense sacred sacrifice to mark the inception of a new epoch. The

fact that this expression has been able to achieve such broad and unchallenged acceptance within the Christian culture shows that, even up to the present, the occult, theosophical meaning of the event described by this word still colours our understanding of what actually took place.

The question remains whether the sacrifice was received and a momentous change from one era to the next actually occurred. Many people feel this claim to be exaggerated and, regardless of all prior acts of destruction, believe that the past can be revived — hence their search for similarities and hidden traces, genetic codes, as it were, which promise to restore the continuity of history. By contrast, the archive of ashes displayed by Rebecca Horn in her installation suggests that the past was definitively and irrevocably destroyed, fully barring the way to any form of restitution. There was indeed a transition from one epoch to the next. This shift precludes the possibility of restoring the link with history, with cultural heritage. It has dissolved and dispersed. For this reason too, any notion of the new has been rendered equally impossible, since the definition of the new is contingent on a comparison with antecedent tradition. New developments could only arise if our cultural archive, the Old Testament, were still intact, offering a framework for determining the novelty of what is deemed to be new. Instead, the cessation of tradition creates a world of perpetual new beginnings. In such a world where everything which went before has now been forgotten, all that remains is the possibility of a future-oriented project. This, however, can never be fully realized and brought to a conclusion, since we lack the criteria needed to judge its success, such criteria also presupposing some form of comparison with the old.

The only tenable prospect is the perpetual return to a new beginning which, at some point and for no apparent reason, will be abandoned, only to be constantly re-embarked upon. When Adorno states that poems cannot be written after Auschwitz, this is evidently not a moral edict, just a simple statement of fact. For in the aftermath of this temporal shift, there is no longer any tradition, audience or adequate public response that would enable a writer to finish his poetry. Nonetheless, this fact certainly does not

prevent one from starting the poem over and over again. Writing about Sisyphus just after the war, Camus succinctly described this new condition of the perpetual new beginning. In certain respects his analysis has remained valid right up to the present day. Though not necessarily the primary cause of this condition, the Holocaust nevertheless remains its unmistakable symptom. For, as I have argued, the Holocaust is not an event which occurred outside art, an event which can somehow be symbolically surmounted through artistic means. This event is in itself intrinsically bound up with the very destiny of art. The only appropriate way of remembering the Holocaust is to preserve the memory of the oblivion that irrevocably separates us from the Holocaust — a memory of the ashes that bar the path of our memory, since this path too has turned to ashes and been scattered. The path leading back has been burnt. Rebecca Horn's installation shows us the archive of ashes as evidence of the dispersal of this path.

Translated by Matthew Partridge

1 Ernst Jünger, *Der Kampf als inneres Erlebnis,* in: *Ernst Jünger, Sämtliche Werke* (Stuttgart, 1980), p. 22 [English version by this translator]

2 Roger Caillois, *Der Mensch und das Heilige* (Munich, 1988), pp. 220ff

3 Derrida also refers to the 'rébellion contre Fénix' in: Jacques Derrida, *Feu la cendre* (Paris, 1987), p. 43

4 Kasimir Malevich, *O Muzee,* in Kasimir Malevich*, Sobranije socinenij* (Moscow, 1995), pp. 132ff

5 For a brief cultural history of crematoriums in Russia, see Semjon Michajlovskij, *Krematorij zdravomyslija,* in: *Chudozestevnnyj zurnal,* No. 19–20 (Moscow, 1998), pp. 12ff

6 On the subject of the relationship between the avant-garde and anti-Semitism, see Philippe Muray, *Das Jahrhundert Célines,* in: *Schreibheft,* No. 26 (Essen, 1985)

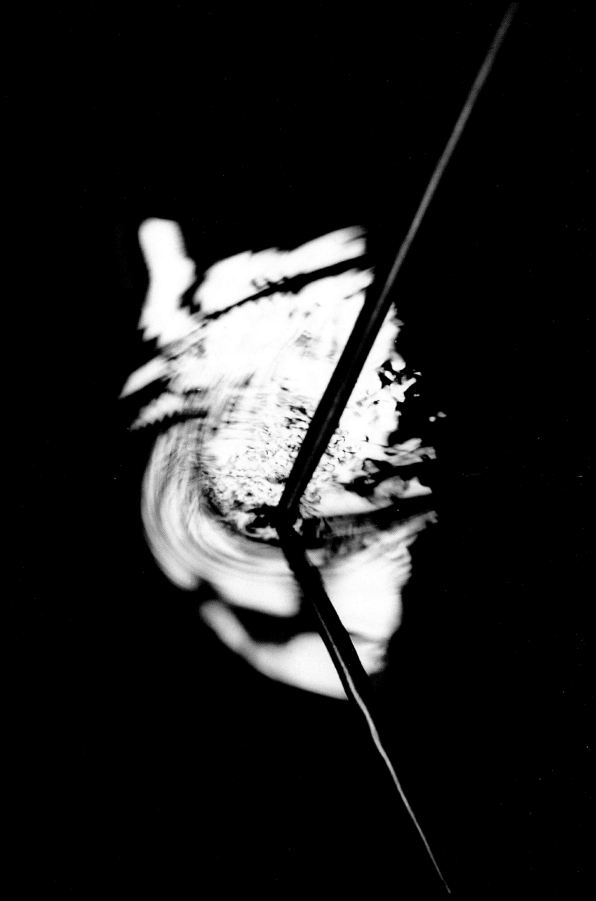

DORIS VON DRATHEN

The clock of revolt

When Jacob approached his father, dressed in his brother's clothes as a subterfuge to obtain a blessing for the first-born son, the blind man Isaac was deceived by the smell of the fur coat and gave Jacob his blessing. Yet a commentary in the Talmud states that the word for clothes, *begadav,* might easily be read as *bogdav*, which means 'rebels.' This double meaning, however, would mean a major shift in perspective. Nothing less is being suggested than that at the very moment Jacob donned the other man's clothes, he had already enlisted all those rebellious descendants who would later oppose the law. In other words, his actions would not only be inscribed in a precisely defined present, but would also extend far beyond the radius of his own actions to play a part in actions that would only properly come about after he had gone. In the course of this textual exegesis, the philosopher and Talmud scholar Emmanuel Lévinas arrives at the following conclusion: 'I can be responsible for things that I have not committed and take on misery which is not mine.'[1]

Sculptural specification

With the manner of formulating political responsibility she adopts in her work, Rebecca Horn is operating with an historical consciousness that effortlessly breaches the narrow temporal boundaries separating the past from the present. By the same token she applies a different scale of precision to her works, using her imagery to unequivocally name the abject depths of so-called recent history. In contemporary historical debate it is the reverse

approach that has proliferated, sharply segregating the present from the past, as if this offered some sense of relief. There is talk of the generation 'born after', as though the burden of past had thereby somehow been surmounted; and finally, there is no mention of Hitler's bio-politics. As terms, genocide or mass murder of the Jews have been supplanted by euphemistic and, to top it all, biblical obfuscations such as Shoa (which actually means catastrophe as divine punishment) or Holocaust (meaning a sacred burnt offering). In many cases, where the act of extermination has even been mystified with terms like 'the unspeakable', 'the unmentionable' or 'the inconceivable', these euphemisms have quite absurdly been assimilated into the vocabulary of divinity.[2]

In her Weimar installation, *Concert for Buchenwald* (1999), Rebecca Horn defines the abyss of genocide in all its unmitigated banality. In Part 1 of the installation she creates an image for the factory of death[3], which eradicated the individual's right to personal death. Ash walls tower upwards, four and a half metres high, twenty metres long. On entering the room people fall silent. In the midst of this former tram depot in the heart of the town, some aspect has been touched on that in the multitude of memorials up and down the country seems somehow to have been overlooked — the simple act of bowing down before the dead. In the context of Christian culture might one not question why prayers are never said for them?

From the horizontal the ash layers shift into a vertical dimension, or — to put it differently — the visitor finds himself in a room which allows the strata of ash to be penetrated like a mineshaft, as if seen from a mole's perspective. These walls offer more than an image, they are the materialization of a reality, the reality of double death — physical murder and personal extinction. And included in the same uncoded imagery are also piles of broken violins and guitars. These mute and dispossessed instruments catapult the past straight into the present. They recall the heaps of spectacles, shoes and clothes that were left behind in the concentration camps, also reminiscent of the roaming hordes of abandoned dogs mentioned in witness accounts. The shredded strings or the shattered bows are more than just objects that, almost as witnesses, evoke a reality: In the work of Rebecca Horn these

instruments also relate their own history. In so many of her installations, lodged somewhere up under the ceiling, you will discover a scraping, sighing violin — if it is not, as indeed occasionally occurs, in a state of mourning. These instruments are clearly brought into close proximity to human endeavour. Always well-suited for being taken by fleeing refugees, the way these silent, demolished instruments here are stacked all along the corroded rails puts them in the role of witnesses, similar to the walls of ash. Shuttling back and forth on a track between this heap and the rear wall is a wagon taken from the former concentration camp that the Nazis, entirely in tune with German pastoral lyricism, had named *Buchenwald* after the surrounding beechwood hills. As though driven by dementia or defective gearing, the spent haulage truck incessantly repeats the same movements, seemingly incapable of ever coming to a stop. The wagon sets off and crashes into the wall, igniting a small flash of light that shoots up the wall; it then rattles backwards, now colliding with the instruments piled up at the other end of the track, whereupon, with piercingly screeching wheels, it moves off again in the opposite direction. However, even though this event might prompt connotations of the soul and of angels, Rebecca Horn calls the bolts of lightening that ascend the wall on impact with the truck 'Jacob's ladder', a technical term derived from physics.

By creating such images she is venturing on a precarious path. Rebecca Horn spurns the security offered by the aesthetic conventions of quotations or passe-partout metaphors. She forges an authentic realm of imagery that is fostered by her own emotional experience and constantly regenerated by the response of the viewer. Not content with merely producing images, she creates something akin to concretely evidential signs. When the viewer encounters his own likeness mirrored in the glass surface of the ash walls inside this large space within Weimar's former tram depot, it is in fact he who becomes a witness. The viewer sees his own image staring back at him out of the layered ash of history — and there is no means of escape.

Implying that this responsibility for the past, this form of personal solicitation, could also be directed at the future, the reflected portrait of the viewer turns and rotates in circular, unstable mirrors swaying to and fro on

the floor in Rebecca Horn's other installation in Weimar. Though both works might initially appear disconnected, they are in fact counterparts—this is Part 2. What Rebecca Horn has accomplished in her second installation is a vision which in quite brutal fashion has long been surpassed by present-day reality. With an energy matching that of moles burrowing horizontal tunnels through the stratified sediments of time down in the town centre, high up in Ettersburg castle facing the Buchenwald Hill there emerges the loud hum of panic-stricken bees flying in circles around their hives, in the seeming attempt to avert desperate trouble. The underground network of earth tunnels corresponds to the system of horizontal flight paths vis-à-vis. This sheds some light on the work's overall title: *The colonies of bees undermining the moles' subversive effort through time.*

Twenty beehives, equivalent to a bee colony, are suspended from the ceiling. The hives are empty and have no bottom. The loud obsessive humming in the room only serves to heighten our awareness of the bee's absence. Instead of honey, the hives are filled with golden light that is reflected off round, rotating mirrors scattered like artificial islands over the floor. Yet the light appears to find no place to rest and flits nervously across the walls. At regular intervals a cobblestone hanging on a rope topples down from the ceiling onto one of these deceptive surfaces, thoroughly shattering it into fine shards with an ear-grating crash. This infuses the room with an inexorable rhythm, as if the place were ticking to the computings of an abacus of terror. In one of the lyrical texts with which she accompanies many of her works, Rebecca Horn refers to 'lost ones casting an axis of escape'.[4] In the course of developing *Bees' Planetary Map,* a project she performed in New York in 1998, which arguably acted as a preliminary study for Weimar—even serving as a temporary working title for the installation in Schloss Ettersburg—her interest in the phenomenon of migrating peoples and refugee movements was of a more general nature. Although at that stage in her work she was acutely aware that these migratory movements were certain to increase, she formulated this artistic concept long before events in the Balkans had come to a head. As a vision of reality, this image has meanwhile been horrifyingly overshadowed by the actual acts of genocide and mass deportations inside

Kosovo. The work in Weimar opens up a dimension oriented both towards the future and the present, while conversely — something subtly underscored by a feature presented in a small adjoining room — the installation in Schloss Ettersburg also addresses the past. Facing a window looking out onto the hillside that leads up to the former concentration camp, directions are being given by a small baton. It is an old Chinese rod that was once hung with weights and used as scales, a fact that spontaneously calls to mind the writing on the wall *mene tekel, upharsin,* meaning 'God hath numbered your kingdom, weighed it and divided it' — or: 'weighed up and found wanting'. Here, though, the scales rod has been transformed into a conductor's baton, mounted at shoulder height on the end of a slender vertical arm. Like a metronome it ticks quietly back and forth, offering each visitor a place on its imaginary rostrum. The casual air about it also portends a diffuse threat, as if ignoring it bode ill. Is the baton conducting the landscape of Buchenwald beyond the window, or guiding the cello placed behind it in the small room that embraces itself with two bows as it plays? Or is it transcribing a rhythm for something that simultaneously belongs to the past and the future? Whatever the answer, the baton evidently embodies the Janus-faced ambiguity that repeatedly plays a crucial role in Rebecca Horn's work, an idiom introduced in this context in the form of the pivoting binoculars mounted on a further rod in the room.

While the baton directs our gaze outside, over and over again the reflective insular platforms, each time starting fresh from scratch, begin collecting the light shining down from the beehives; moreover, they also capture the portrait of the viewer. The searching cones of light are interspersed with the likenesses of all those present — every single person is also solicited to find a centre, a centre of their own. As in so many of Rebecca Horn's works, it is the process of lengthy probing observation that ultimately leads the viewer to his or her own self. The actual rebellion prompted by these works is always one and the same, a revolt in its most basic sense. Since it is always the immediate presence of the viewer brought face to face with himself that crystallizes as the theme and a component of the work, revolt is not formulated as an uprising mounted against history or continuing in-

justice, but also and primarily as an inversion and a turning back, as the un-affectedly self-evident call to return to the centre of the self. This sheds light on how to view Jacob's borrowed clothes mentioned at the start of this essay, as 'rebels down to the skin'. While the viewers are immersed in the 'borrowed' signs generated by Rebecca Horn, thereby adopting her 'bor-rowed' memories, they shroud themselves in a rebellion that has yet to be-come or has now ceased to be their own; they nonetheless absorb it so as to be able to turn back towards themselves — 'Je me révolte, donc nous sommes à venir'[5] (I turn back, thus we are evolving).

These two thematic strands, individual fate in its relentless quest for a centre and the drama of a people that has lost its roots and whose centre has been destroyed, are interwoven in this work and call to mind something Saul Friedländer wrote in his autobiography: 'The uncertainty has always stood for our manner of existence in the world and has made us what we are, for better or for worse. Sometimes, when I consider our history, not the recent past, but its entire span, I see the figure of a ceaseless to-and-fro, a search for roots, normality and security that has been undermined again and again throughout the centuries. And I ask myself whether the Jewish state itself is not simply another stage along the journey of a people that, with its specific destiny, its incessant search, its moments of hesitation and renewal, has become a symbol for all humanity.'[6] In discerning the universal in the particular, Rebecca Horn's signs are conferred the status of novel, arche-typal images capable of touching the viewer without circuitous recourse to academic commentary.

In the village of Stommeln close to Cologne stands a synagogue, one of the few in Germany to have survived the period of genocide and the destruction of Jewish cultural institutions. Almost miraculously, during the pogroms a farmer used this small, rectangular building on the perimeter of his land as a barn. The only reminder of its former function was the six-pointed star in the windows. When the Nazis came to burn down the syna-gogue the farmer defended the building, pointing out that it had ceased to be a house of prayer as it was now his barn. Concealed behind a row of houses, it was rediscovered and restored just a few years ago, even though no one

Mirror of the Night, Stommeln synagogue, 1998

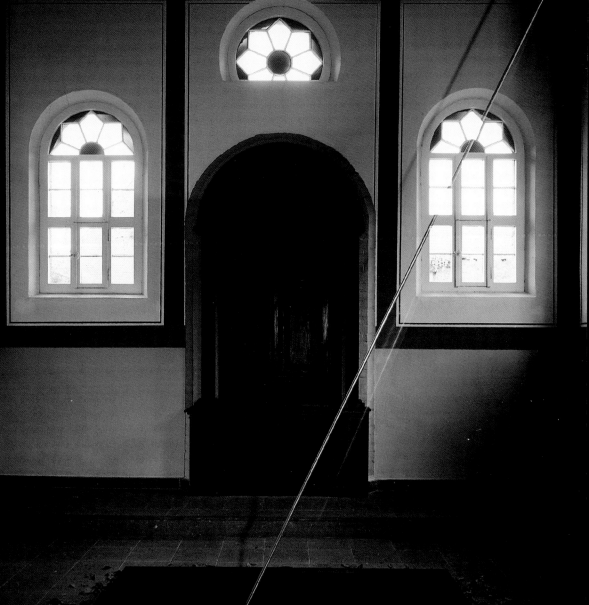

has yet been able to reassemble its congregation. Inside, the building is hushed and empty.

In 1998 Rebecca Horn created a work on this site, a universal idiom which manages to link together Jewish and Christian traditions, yet by the same token also transcends both. Once again her imagery does not seek to accommodate narrow academic discourse, but is generated by the desire for an artistic formula of emotional intensity; it is the evident boldness of her purpose that makes this installation so exceptional. Essentially, *Mirror of the Night* is a work concerned with marking or constituting a specific site. A golden needle five metres long which penetrates the entire height of the synagogue, right through the centre of the area where the *bema* is kept, can be read as a kind of axis. This represents one of the most primeval designations of the centre of the world, a rod connecting heaven and earth along an *axis mundi.* However, although the needle is secured to the ceiling, the very material from which this golden axis is made paradoxically lends it the impression of being unattached, of flowing with the graceful immateriality of a beam of light. The needle starts moving at rhythmic intervals, gently stroking the perfectly smooth surface of burnished water beneath it, a black basin lying there, spread out like an enormous, open book. With shaking, twitching movements the needle inscribes characters from left to right and from right to left — all varieties of figures — disrupting the water's plane surface. Etching its signs into the skin of water, the golden stylus wounds the surface, causing it almost to bleed. The lines begin to blur and branch out like neural paths. When the needle falters, the surface temporarily smooths over again. Then a large black, fathomless mirror reappears once again, evoking an eclipse like the one Buber once described: 'But a night comes and a wall of world rises up before the soul and obscures its course and view. (...) The path vanishes. A finger has extinguished the light of all the stars and the promise of all the heavens. Where once the vanished path lay, a dark wall now cranes into the night.'[7] Enveloped in such darkness, the inscribing flash of light appears to offer succour. It is not merely the possibility of its movement over the black water reviving the luminescence of the stars — this patient writing of signs also reminds us of weaving as a means of not forgetting, as though

52

this image were actually formulating something once described by Celan: 'Brought home, syllable upon syllable, distributed / among the day-blind dice (…).'[8] The huge writing from left to right and from right to left omits nothing and no one, almost as if this continual flow of writing, erasure and rewriting could, akin to the motion of the ocean's breath, encompass all things.

Indeed, the book is also somewhat like a home, a *macom* — that inner-most, inalienable house that all believing Jews carry within them. It is pre-cisely when she converts the written sign into an element marking her location that Rebecca Horn's 'open book' touches upon one of the greatest secrets of Judaic mysticism: 'Je suis dans le livre. Le livre est mon univers, mon pays, mon toit et mon énigme. Le livre est ma respiration et mon repos'[9], as Edmond Jabès writes. Equating the *macom* with the book takes on an additional dimension in the permanent movement of the sign as it emerges, expires and then resurfaces. Here too perhaps, Rebecca Horn's sculpture evokes an ancient rule of the Jewish tradition: Talmud scholars distrust the written word, because in the very act of being written the word dies. Tradition must breathe, it must be transmitted from mouth to mouth, from ear to ear, as indeed Buber's description of how Hasidic legend was handed down makes clear: 'Not in the shadows of ancient groves nor on silver-green olive slopes did it grow, but down narrow lanes and in musty chambers it passed from awkward lips to anxiously listening ears. It was born of a stammer, and stammers bore it further — from generation to generation'.[10] Mounted in one corner of the room is a violin from which, in an unvarying rhythm, the same drawn-out notes are repeatedly extracted by a bow. In a certain sense the stuttering described by Buber appears to be echoed in the sighing lament of the violin; or else it seems as if this conveniently transportable instrument, a constant feature of Jewish culture since time immemorial, were summoning up the voices that once loudly recited the monotonously repetitive prayers on this site.

But since the signs exist only at the very moment of writing, similar to how the spoken word emerges and vanishes in a single breath, they are permanently kept alive. This calls to mind the paradoxical vision of a form of erasure that enables something to be recorded and protects it from being

forgotten, the enigmatic vision of a process of forgetting that preserves memory — 'brought home to oblivion' [11], to use the words of Celan — as if the expiation of signs manifested the most fundamental truth. This is echoed by an old cabbalist legend: 'At the end of the path lay a large stone on which a very old man was seated. He held a stick in one hand and was tracing signs with its point in the sand by his feet. But the rabbi bent down to the man who was writing and asked, "What are you doing, old man?" Without looking up from his work or interrupting what he was doing, the old man replied, "Can't you see that I'm writing the book of the seven seals, the book of life?" — "But why", asked the rabbi, "are you writing it in the sand? A wind will come and blow it all away." — "That", answered the old man, "is the very secret of the book".' These connotations of Jewish traditions are interwoven with Christian references, but maybe also with the idea of establishing a curative and redemptive place, maybe with the sense of an essence, of a substance that survives. Whoever is driven by curiosity to lean over the edge of the black bath and read the signs will encounter his own likeness — for it is in his own reflection that the viewer experiences the real and urgently immediate transformation of this site.

Like an echo, *Mirror of the Night* is reminiscent of a further work involving a damaged surface of water that already fifteen years earlier, in 1984, Rebecca Horn created in New York. Over a black basin measuring 30 x 420 x 220 cm swings a three-metre long steel pendulum that sends vibrations across the water's surface. There is a certain inexorability about this constant repetition, like the spring of a clock unable to stop trembling or an earth tremor that never comes to rest. In *Livres des Questions* there is a verse Jabès wrote: 'One evening in a village in central Europe the Nazis buried several of our brothers alive. For a long time after, the ground continued quaking with them in pulsating waves. (…)' [12] This calls to mind a notion of history which, self-propelling, continues to unravel of its own course; as Bergson puts it, '… let us for a moment assume that the past persists as stored memory in our minds. In order to retain memory, the brain would first of all also need to be preserved. Yet our brain (…) can only absorb the present moment, and along with the rest of the world also constitutes a per-

manently renewed cross-section of the general state of being. So one will either have to suppose that through a genuine wonder this world perishes and reemerges in every single moment of its duration, or else one must transfer the continuum of existence (a quality denied to consciousness) onto the world and turn its past into a reality that extends beyond itself and persists autonomously in the present. Thus nothing is gained from stuffing memory into matter; on the contrary, we are faced with the necessity to extend this entire, independently continuing existence of the past (…) to cover all conditions of the material world. We find the principle of the independently continuing existence of the past so difficult to grasp, because we project the necessity of containing or being contained onto the range of memories within time, memories that apply only to the totality of bodies we momentarily perceive in space. Our fundamental illusion derives from the fact that we project the form of momentary cross-sections performed on the span of time onto passing time itself.'[13]

This is why every act of defining a place is inevitably always a response to the earth tremors which, to use George Steiner's words, are of a universal nature: 'A society requires antecedents. Where these are not naturally at hand, where a community is new or reassembled after a long interval of dispersal or subjection, a necessary past tense to the grammar of being is created by intellectual or emotional fiat. The 'history' of the American negro and of modern Israel are cases in point. (…) There is hardly a civilization, perhaps hardly an individual consciousness, that does not carry inwardly an answer to intimations of a sense of distant catastrophe. Somewhere a wrong turn was taken in that 'dark and sacred wood', after which man has had to labour, socially and psychologically, against the natural grain of being.'[14]

This line of argument leads one to mention another work which at first sight appears somewhat puzzling: suspended in the midst of an open circle of five doors is a large compass needle fixed to a rod. As the needle rotates, it inflicts wounds on the frames of the doors, makes incisions, cutting a sort of boundary through them. In the sense of the maxim 'this far and no further', the vertical compass delineates its territorial space. This 1993 work is called *Cutting through the Past* and can be read, together with the others, as a

secured demarcation of space. This perspective is confirmed by a remark voiced by Rebecca Horn herself: 'One is constantly subject to the temptation to waste oneself. In my life, this temptation was so extreme that I was continually rushing headlong into an almost suicidal state of exhaustion, something I was only able to endure by always coming back to this circle of centredness.'[15] With this very personal testimony Rebecca Horn nonetheless achieves a universally valid insight which Warburg expressed somewhat differently in his writings on Mnemosyne: 'The conscious creation of distance between the self and the external world may be called the fundamental act of human civilization. Where this gap conditions artistic creativity, this awareness of distance can achieve a lasting social function.'[16]

It is here that the dimension of Rebecca Horn's imagery becomes evident: her signs are an artistic idiom which creates immediate awareness of inescapable proximity, while conversely, the very use of signs establishes a necessary detachment for a clarifying, ordering, reflective space.

However, in some of these spaces the viewer becomes voyeur. In 1997 in Münster Rebecca Horn transformed a room in the museum facing the cathedral into, metaphorically speaking, the scene of a crime, somehow suggestive of the sequence of opening doors in Bartók's opera *Duke Bluebeard's Castle.* Having thrown open the final door, Judith peers beyond it into a vast expanse of night. Her silence and fathomless desolation echoed in the tonality of the string section leave no doubt as to the true nature of this nocturnal darkness. Yet the act of opening doors is an archetypal image for the human search for orientation in the world and in history, the desire to shift the horizon.

This is precisely what Rebecca Horn ventures to suggest in her room composition *Les Délices des Evêques.* In a conversation several years ago concerning the figure of Bluebeard, whose trail of murders continues unhindered until he finally kills the king, Rebecca Horn argued in her inimitable, freely associating train of thought that, 'this fairytale is wrong. In fact it is completely illogical. Bluebeard should have continued to live. For me he possesses an essential energy that will always reappear, that never comes to an end; the old people called it 'rolling on into the next war', like a ball that

hits something and on impact releases new energy. Bluebeard has this vital-
ity and at the same time a craving to destroy — this energy is never used up,
it persists forever.'[17]

By opening the door onto the murderous *Délices des Evêques,*
Rebecca Horn deploys all means at her disposal to stage a forever recurring
present. The rooms offer no form of shelter, no ray of hope, all one finds is the
crude event of the act itself, the inescapable vitality and never-ending repeti-
tion of the intransigent pendulum and the perturbing interchangeability of
observer and observed.

The room's tall windows are screened from the outside world with
white curtains. At eye level two pairs of binoculars are balanced on long thin
rods. They are located behind slits in the curtains, allowing the viewer to look
out onto the cathedral and the old bishopric opposite. Yet these instruments
constantly twist and turn away, and the viewer, initially immersed in his sur-
veillance of the world outside, discovers in the next instant that he himself is
being observed. What at first was directed at the past now turns to survey
the present and the future. It is only through such Janus-faced movements
that historical inspection achieves true significance for Rebecca Horn.

Blood sprayed across the walls and the floor. Swinging to and fro
through the room is a prayer stool, flying higher and higher and plummeting
down in a murderous arc towards another prayer stool which is fixed to the
wall. Mounted horizontally onto the chair's backrest above the seat — or, to
use Rebecca Horn's words, at the same height as the solar plexus — are two
delicate metal rods which open and close like 'fear tentacles'[18]. Just as, and
only when, these insect-like tentacles slowly and tremblingly open out, the
other, free-hanging chair coils back and, on gaining momentum, surges for-
ward — almost as if its lethal impetus had just been triggered by these un-
folding, quaking sensors, as if 'aggressor' and 'victim' were both engaged
in some secret dialogue. Following the momentum of the big swing — one is
even tempted to say: the 'act of crime' — the suspended chair continues to
sway back and forth until it finally comes to rest. Its counterpart has mean-
while retracted and closed its metallic feelers which — to quote Rebecca
Horn once more — now resemble a 'protective armour.' As so often occurs in

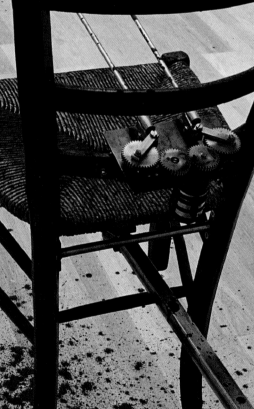

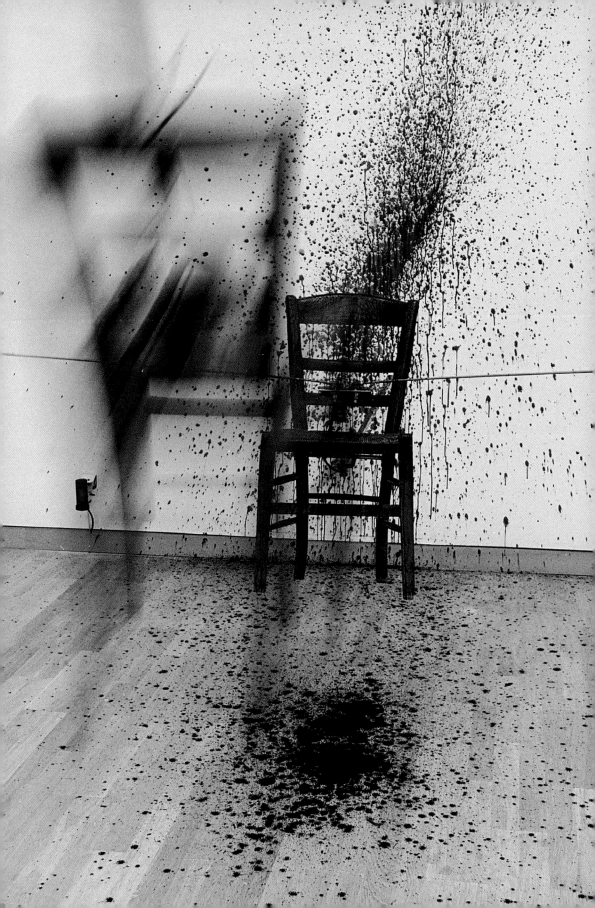

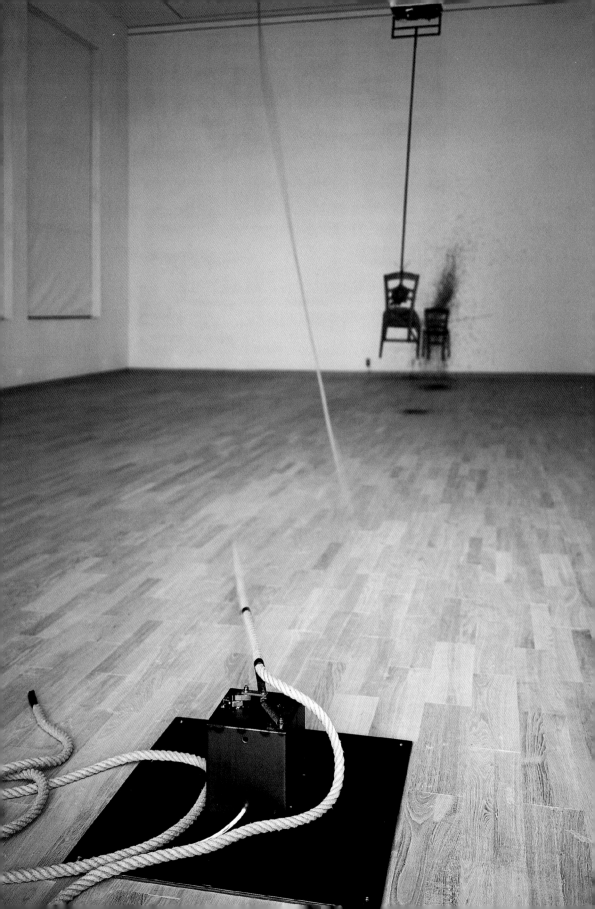

her room installations, this endlessly repeated operation is accompanied by a violin situated high up on the wall and continually reiterating the same sighing notes. Without ever losing its rhythm, the symmetry of this mechanical composition is disturbed by a bell-rope hanging from the ceiling, which whips diagonally across the whole length of the room. A further component of the installation is a row of prayer stools lined up against one wall. The viewers also form part of this picture, are both participants and eyewitnesses of the executionary apparatus repeatedly performing its operation. Its mechanism functions with lethal, inexorable precision, a sort of absurd time lapse whose drama through time, silence and oblivion is smoothed out like a swing gradually coming to a rest, until it once again erupts from the very evenness of oblivion. The force of impact generated by the bell-rope is related to the plummeting cobblestone in the Schloss Ettersburg installation; here it seems to act almost like a time lash that whips an event from the past back to life. Or is this whipping an allusion to that 'empty space between the layers of time'? That incalculable moment referred to by Broch when he describes the 'empty void' that 'suddenly opens up, the void for which everything comes too late and too early, the empty chasm of nothingness beneath time and beneath the times which time itself, fearfully and paper-thin, seeks to bridge over by lining up one moment after another, so that the petrified-petrifying chasm is rendered invisible.'[19]

Precisely which chasm of history is the subject of this scenario? In Weimar the historical facts were at least clearly identified in Part 1 of the installation. In *Délices des Evêques* the clergy is summoned as an unimpeachable institution to attend proceedings held at the site of the crime, as if the victims of torture and persecution were now assembled to put it on trial. Here the crimes of the Inquisition, or more recent atrocities, are being evoked with equal vehemence — much as if the sanctuary lamps fixed to the wall were an ironic, even sarcastic reference to a quite different concept of timelessness. The Inquisition prescribed the death penalty for anyone who read books in foreign languages or philosophical writings. In the 15th century the church issued decrees ordering all inhabitants of Spain to prove the 'purity of their blood', and no one with Jewish, Marrano or Moorish ancestors was

tolerated. An equally punishable act was the lighting of Sabbath candles or eating kosher food. Just how far is Spain from Münster, how distant is the 15th from the 18th century? In the early 19th century, when Goya showed civilians strung high up on the gallows swaying through the pictorial space of an etching, his enemy was clearly identified; the successive plates of his series *Desastres de la guerra* were a demonstration of his solidarity with the popular uprising against the despotic rule of the crown and its capricious ministers — in other words, against Charles IV and Godoy — discontent that also took the clergy in its sights. In the aforementioned etching[20] a monk can be seen approaching the hanged men in an attitude of sanctimonious consolation, as though the cleric were a figure present at the Descent from the Cross. Goya's attacks on the clergy were so clearly formulated that even in his preparatory drawings for some of the etchings they could easily be made out. The bishop he depicts dancing like an acrobat on a tightrope in one of the *Desastres* plates is portrayed in a preliminary sketch wearing a papal tiara and bearing a facial resemblance to Pius VII. But in the final etching[21] Goya then retracted these contemporary references, retaining only the bishop's robes and the proclamatory gesture which he nonetheless parodies as a circus-like balancing act. Yet although the general mood of *Les Délices des Evêques* might be reminiscent of Goya's etchings, Rebecca Horn did not have this pictorial tradition in mind as she was preparing her installation; instead, as so often, she was working with unerring intuition. In contrast to Goya, her approach to history does not allow her to personify the enemy, the perpetrators or the guilty as clearly defined figures; rather, she is concerned with thematizing institutionalized, legitimated crimes, focusing on the apparatus of death and the destructive energy that always seems to erupt from it. Her depiction of the culprit is in fact more analogous to those criminals Habermas once described as 'operating at the outcome of a complex chain of events'[22]. But Rebecca Horn goes even one step further: victim and offender both destroy each other. The victim fights back: the 'hanged man' poises to launch a murderous swing; then his opponent, set in a somewhat judge-like position, is attacked and both are drenched in blood. Bluebeard, Macbeth? The room's whip appears to condense time and space,

to collapse history into a single momentary event, formulating the deed itself as a vociferous indictment.

It is precisely this aspect of these sculptures that makes them new and unique: in Rebecca Horn's work images become events. The spaces she composes as total ensembles are governed by other rules than the ones pertaining to architecture. Her sculptural and choreographic manner of dealing with space and her strong sense of formal composition correspond surprisingly closely with Gilles Deleuze's theory of the distinction between partitioned and open spaces (*espace strié* and *espace lisse*). In this respect Deleuze's analysis suggests ways of grasping the transformation Rebecca Horn has achieved, the possibility of perceiving space, not in terms of its measurable dimensions, but in relation to haptic experience. She succeeds in translating a closed volume into an open space occupied by 'object-events', by *heccéités* (as Deleuze describes his *espace lisse*), a kind of space that, like the desert, can be experienced by the scraping sound of sliding sand, or like the Antarctic, is vividly represented by the noise of splintering ice or the howling wind. Rebecca Horn surpasses mere visual impression by inventing sculptural events that take on haptic materiality. In her installation spaces, lines become vectors, time is transformed into a single moment and the location itself becomes an event. In this context, the actual technique displayed by her kinetic sculptures is less important as such; its perfection lies in rendering their motors invisible. The thematic issue enacted here is not their movement — what matters most is the transformation of the objects into directed energies, into catalysts whose alien 'selfhood', i.e. their autonomous occurrence as events that announce 'Here I am', launches a spatial dialogue. The viewer is drawn inside this magnetic spatial field. It is only in the intervening space between the viewer's presence and the autonomous existence of the sculptures that these events can occur. It is only through the experience offered by this dialogue that the installation spaces can be upset and unhinged. By including the row of chairs, or the binoculars at eye-level, in the overall room composition of *Les Délices des Evêques,* the viewer's position as observer is not only formulated in spatial terms, but, disturbingly, is also invested with connivance, if not complicity.

Whether intentionally or not, the art consumer becomes a protagonist, maybe even the conductor of an apparatus with which he would rather not be associated.

Compiling history as revolt

There is one pictorial figure frequently found in Rebecca Horn's work that seems to act in direct equivalence to the navigational device of a ship's echo-sounder: a kind of visual reflector, or something that might be described as a mirror-sounder. In 1986 for instance, in the Viennese Theater am Steinhof, which is part of Austria's largest psychiatric clinic, she created a room installation called *The Ballet of the Woodpeckers.* Caught between two mirrors facing each other, an endless series of reflecting cabinets opens up, telescoping back in an infinitely boxed-in suite of rooms. This visual obsession is echoed by an acoustic counterpart, the sounds of pecking and hammering played in constant repetition with an indefatigably regular rhythm. On one mirror delicate hammers can be heard tapping away, while two black-and-white mottled feathers are seen drumming against another mirror before they rapidly lurch back. Their sound becomes a silent movement in the glassy depths. This act of pecking, followed by a flinching recoil, alludes to something Rebecca Horn observed in the psychiatric clinic, where patients passing by an old mirror in the building would frequently turn to look at the reflection and then, on each occasion, would suddenly jump back in fright at having encountered their own image.

As with so many of her works, this piece not only has a title but is also accompanied by a text she wrote that tells the tale of the *Sicilian Palace Journey:* 'In the days of the crusaders there once lived a prince in Sicily who was obliged to do penance by visiting the birthplace of Jesus Christ. Since his wife was very ill he did not dare leave his country. He locked the gates of his palace against prying eyes and, accompanied only by his manservant, he set off alone on this solitary journey — a journey through each room of his palace. Finally, after months of the most gruelling ordeals, they reached the Promised Land on the ridge of his own palace roof.'[23]

The Sicilian Palace Journey, Theater am Steinhof, Psychiatric Clinic Vienna, 1986

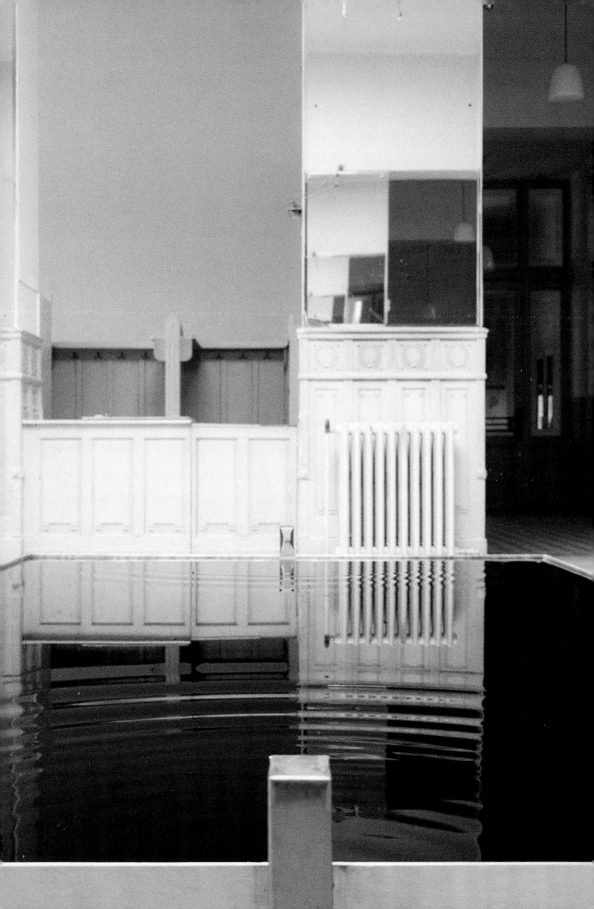

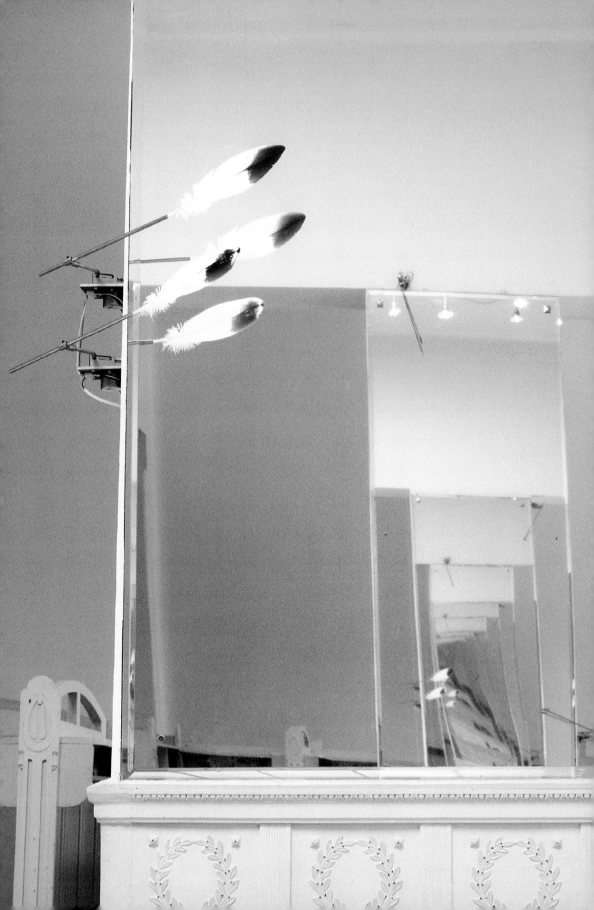

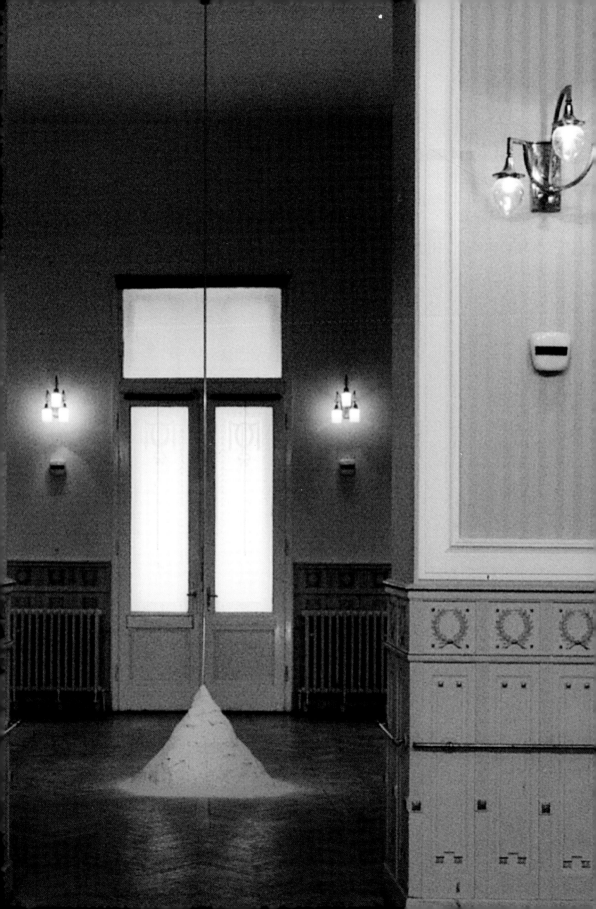

Similar to a spiral movement that leaves after stenuous exertions the ground, but gradually gets lighter the higher it coils upwards, like the moment of looking inside oneself that opens up our vision for the infinite distance of a mirror, image and text are merged into a thematic thread, a leitmotif that runs throughout Rebecca Horn's entire oeuvre. With the images of her mechanical sculptures and installations she appears to be evolving an immense stream of hieroglyphic language which, over and over again, regenerates universal encounters and experiences as events in the present. Correspondingly, this work itself evolves in a spiralling movement. Whereas modernist assertions that we have lost our centre have long since become tradition, and collage and the Mallarméan fragmentation of signs and designations have now too become classical standards, Rebecca Horn has for decades unswervingly been creating a world filled with authentic images that not only manifest the theme of such a centre, but even manage to transform it into an event the viewer himself can personally experience.

It is part of these images' singularity that sounds, like the scraping of the ever-present violins, the knocking of little hammers or even the 'plop' made by a drop of water falling from the crown of a tree or the ceiling into a basin of water on the ground, are also awarded the status of sculptural elements. Throughout her work, space, objects, movement and sound are all organized into the sequence and rhythm of an extensive composition akin to a musical score. Hence in terms of Rebecca Horn's artistic rationale, it comes as no surprise that even a project involving the exposure and appropriation of an ancient fortified tower, the city keep of Münster, is given the title of *Concert in Reverse* (1987). When she came across this site, the thick walls were covered in a sprawling mass of ivy and elderberry bushes. The roof was missing and doors and windows were bricked up and hidden by dense undergrowth. No one in Münster was prepared to open up the tower, furthermore, no one had even bothered to ask why in fact not. When Rebecca Horn chose this site for her artistic intervention in the sculpture exhibition 'Skulptur-Projekte in Münster' in 1987, the town's response to her decision was equivocal. Part of her approach is to first unveil and then incorporate a place's hidden history into her own work. With fine precision and

Ballet of the Woodpeckers (left), The Sicilian Palace Journey (right), Theater am Steinhof, Psychiatric Clinic Vienna, 1986

terse sentences in the style of a trial transcript, as if imposing restraint on the account of some extraordinary scandal, she documents the results of her findings in the town's archives, introducing facts almost as though they were protagonists. In her text she relates: '(...) The former tower was finally converted into a prison in 1732. Johann Conrad Schlaun drew up the new plans for the building. The prison became part of a complex with two wings for a penitentiary. Six cells were built into each of the tower's three storeys: those in the cellar were without light, the cells on the ground floor had each one small window looking out onto the circular inner courtyard, those on the top floor not only had windows but could even be heated. The prison was shut down at the end of the 19th century. In 1911 the city acquired the tower which has, in the meantime, been declared a historical monument. With a few structural changes it was used for emergency housing after World War I. A painter was among those who took up residence there. In 1938 the keep was turned over in an official ceremony to the Hitler Youth, which moved into the newly renovated and furnished assembly rooms and quarters for German youth. Towards the end of the war, the building was taken over by the Gestapo. Polish and Russian prisoners of war were executed in the light well, the technique being to hang four people at once. In the last year of the war bombs destroyed the roof and the inner courtyard. The city bricked up and barricaded the windows and doors from the outside to prohibit entry in an attempt to banish the atrocities of the preceeding years. Cut off from the outside and yet exposed to wind and weather by a gaping wound from within, the keep gave way to the timid growth of new organic life. Trees reaching up to the skies took root in walls and windows. Ferns and moss grew rampant over stairs and passages until a lush garden of paradise emerged, covering the naked masonry with plant growth.'[24]

This text is so extensively quoted here because, without any further additions, Rebecca Horn's bare, inventory-like description manages to formulate the second crime connected to this tower. She identifies the keep as a fifty-year old instrument of silence, a straitjacket designed to prevent its history from being perceived. With a minimum of effort, yet driven by a sensual imagination coupled with extreme precision, she succeeds in

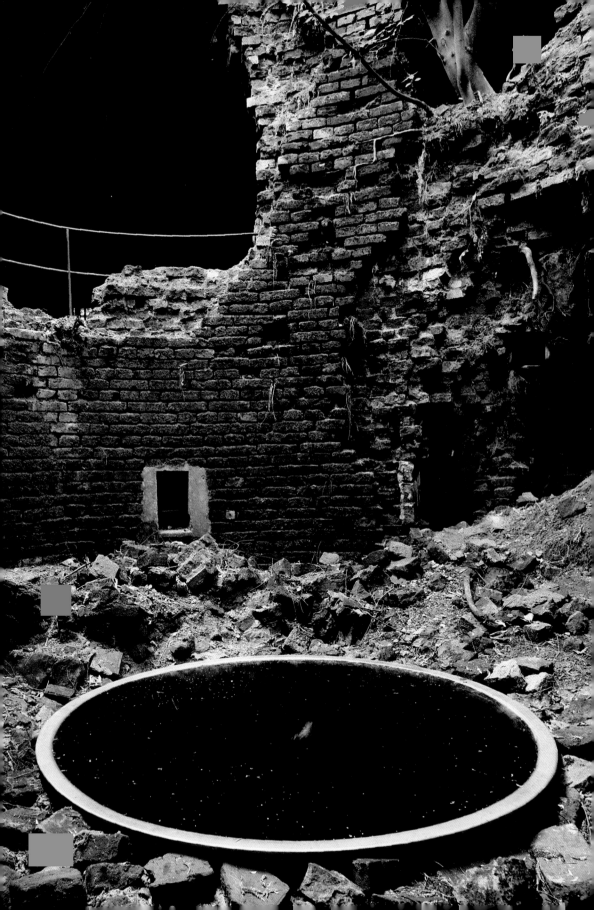

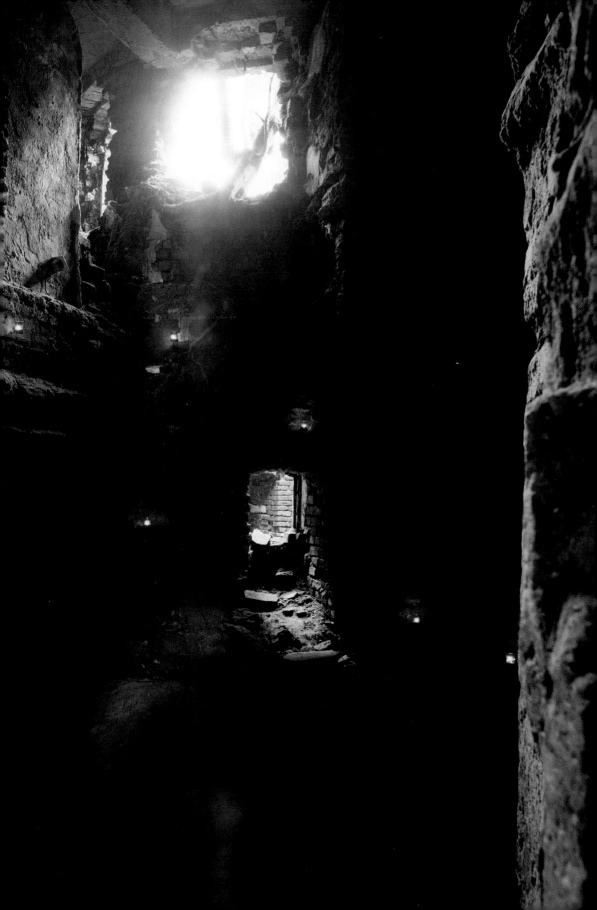

transporting her knowledge through her pictorial language, in lending tangible immediacy to her awareness of history. This first involves opening up the tower, cutting a path through the dense undergrowth and entering into the forbidden place. In doing so, she uncovers a form that is later to play a key role in a whole series of sculptures and room installations, the ascending spiral. The tower consists of a dark, low-ceilinged, catacomb-like passage that is tightly wrapped around a circular inner shaft and twists up towards the light. Still blinded by daylight, one's eyes are slow to find orientation. Little oil lamps appear to be standing guard, conspiratorially illuminating the ancient brick walls; yet rather than light the way, they reveal the eeriness of this place: in Rebecca Horn's terms, these are the earthbound souls of people who were murdered there[25]. The ground is uneven and sandy. Somewhere out of the hushed darkness comes a sound of knocking. Clicking and rapping noisily in shifting rhythms, forty fine metallic hammers drum incessantly against the walls as if the tower were damned to eternal unrest. The higher one gets, the louder the hammering becomes. The passage finally opens out onto a platform jutting out over the round, twelve-metre deep shaft. Having suddenly re-emerged into daylight one might perhaps breathe a sigh of relief, were it not for the knowledge that the Gestapo forced its prisoners to construct their own gallows on precisely this spot. This is where they were hanged before being dropped down into the depths of the shaft. Cautiously nearing the railing of the roofless ruin, the visitor might venture a glance into the depths below — and find himself looking into a smooth, round mirror of black water. What one sees is a section of sky, foliage and the whitish shape of a funnel, until an echoing plop of water abruptly disperses the picture into ripples of water. One's gaze automatically shoots upwards, only to discover a sweepingly curved funnel attached to trees growing towards the sky out of the tower's old stonework. Every twenty seconds a single drop of water is released from the funnel and falls fifteen metres down into the water basin below. For the duration of the 'Skulptur-Projekte in Münster' in 1987 Rebecca Horn also installed a glass terrarium housing a pair of snakes. In her own description the snakes were 'earthbound', and 'fed daily on a Münster mouse, they observed and controlled the comings and goings for months on end.'[26]

Concert in Reverse, Skulptur-Projekte in Münster, Münster, 1987

Yet the installation itself is rendered earth- and skybound by a connecting axis constituted by nothing more than the dripping water — or by the reflected image repeatedly dispelled by the ripples of water. Or, yet again, by the ascending spiral of hammering. This *Concert in Reverse* is determined by ephemeral elements that are constantly in motion. It steals itself into already existing surroundings; yet while they do not constitute the primary theme, they are occupied here and there by vigilant, sentinel markers. Nothing here is snatched from the dark depths of history, nor is atonement with the past the issue in question — here the past is simply transformed into a site where the present can simultaneously occur with the highest degree of immediacy, a place which calls for individual presence of mind and alertness. Like seismographic geodesists, the snakes act as a metaphor for an instrument that registers past and present, indicators that are sensitive to even the slightest danger. Standing up on the platform, whoever leans over just a little to take a longer look into the depths will encounter his own image.

By thus heightening awareness for a sense of responsibility, an involvement precisely also with the past, Rebecca Horn proceeds as though she were reminding us of signs that are not easily seen or heard. In his exposition of the 'dialogic principle' Martin Buber's examination is not merely restricted to the dialogue between an assumed Me and You. Indeed, one of his key issues is that world history should be treated as a concrete entity that, as Buber says, 'looks at me'[27]. In an attitude of stubborn and radical dismissal of all superstitious clichés whatsoever, the philosopher postulates that: 'Each of us is wearing an armour designed to resist signs. We encounter signs un-remittingly, life means being addressed. All we had to do was to take it on, was to listen. But for us the risk is too hazardous, the noiseless thundering seems to threaten us with destruction, and from generation to generation we perfect our protective apparatus.'[28] As he continues, his words sound increasingly like the urgent warnings of a great sage: 'The signs of an address are nothing out of the ordinary, something that departs from the order of things (…). What I experience is speech being addressed to me. That which I experience is world history speaking to me. Only if I sterilize it and strip it of its capacity to address me, can I treat what happens to me as a part

of world history that does not concern me. This self-contained sterilized system, with which all this simply needs to merge, is the titanic opus of humanity.'[29] Rebecca Horn's pictorial language is composed of such signs; alien to academic statements on art, these possess the particular potency to penetrate our cultural armour, and can become assimilated into what Buber calls the 'world concretum'[30]. Today, when a visitor passes between the old walls of the keep, peers with curiosity into the shadows and finally reaches the platform imbued with a sense of apprehension, he has automatically become an accessory. This is the other reverse movement offered by this composition: once immersed in this site of memory, one is subjected to the experience of this memory, as if re-living it in the present, whether it belongs to one's own past or not. The memory of offender and victim in equal measure. And no one will be able to say he was born later and was therefore not involved. The signs' vigourous energy and permanent self-reinvention relentlessly point to what is happening now and what will happen tomorrow. For the present is not something that simply is, but an event that is taking place, over and over again — even if the event is merely a drop of water falling.

This element again represents something akin to a metronome that scans the segment of time the visitor spends with these works. On entering Rebecca Horn's time-space vortex the clock of revolt starts ticking, the chronometer of radical change which might enable the viewer to find the Promised Land waiting on top of his own roof, or which in his own likeness reveals his part in history, or which evokes the Hasidic legend of the peasant who sets off in search of a treasure believed to be in Warsaw, only to learn on his journey that the treasure is buried in his hearth at home.

The revolt evoked by Rebecca Horn's work runs counter to all aesthetic conventions, simply at least by the way her images constantly formulate the drama of individual existence, the moment when someone ventures out from his ordered routine as a citizen and subjects his identity to the examination of personal experience. In the light of this, it is then hardly surprising that Rebecca Horn also views the Passion as a rebellion — as can be seen in *Rio de la Luna* (1992), her large installation spread over several sites in the city of Barcelona. Here the Passion is formulated as dramatic energy, as a

El Lucero Herido, Barcelona, 1992

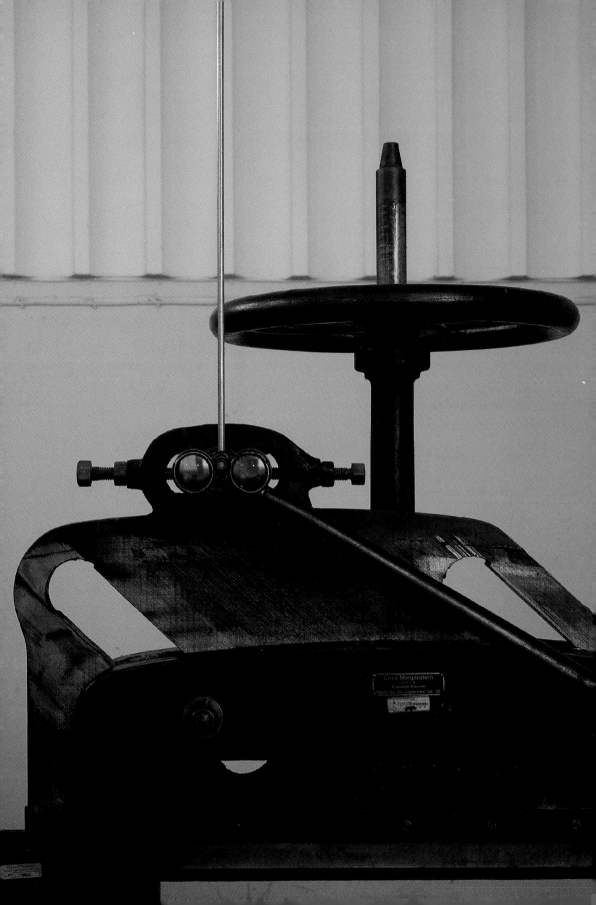

path charted along the narrow margin between heaven and hell, between creation and destruction, between the intoxicating proliferation of the ego and the terrifying sacrifice of the self, between being the receiver of gifts and the fear of loss. Her images show the Passion as turbulence, as the most powerful form of revolt and revolution an individual might possibly experience, as the dual moment that promises both a new beginning and threatens final termination, the moment that catapults all order into chaos. Rebecca Horn opens up the theme of passion in a ramified web of mercury streams propelled through lead pipes by a large pump moonwards and seawards. This image is a recurrent motif underlying an entire work complex, treating energies, currents and winds as movements that traverse the world. At various points along their course one might imagine finding funnels that channel these mercury rivers, located within the 'heart chambers' of an old seedy hotel, each of which—from a sky filled with violins to an encounter of mutual destruction—is dedicated to a particular period of time.

There is a surprisingly close correspondence between these 'heart chambers' and another work installed on the seafront of Barcelona which was created at the same time. Here a ramshackle, rickety tower has been cobbled together from stalls and huts piled precariously on top of each other and is called *El Lucero Herido,* the wounded falling star. These *chiringuitos* were once used by beach vendors for selling drinks and churros. When the government decided to sanitize the beach by bringing in white sand, planting palm trees and erecting pompous promenades, these stalls were simply torn down, even though for their owners they had meant something like home. They were self-built and year in, year out after the winter storms had been painstakingly repaired and patched up. On this same beach Rebecca Horn constructed a memorial to this traditional way of life: inside the pile of huts and set behind reflecting windows, flashes of light shoot upwards. Climbing up from cube to cube, these disjointed Jacob's ladders are a leitmotif that constantly recurs throughout her work. It is almost as though the bolts of lightening were holding vigil in a endlessly repeated rhythm of upward movement. And they too, one could say, function as a metronome, in this case as a metronome ticking with rebellious light.

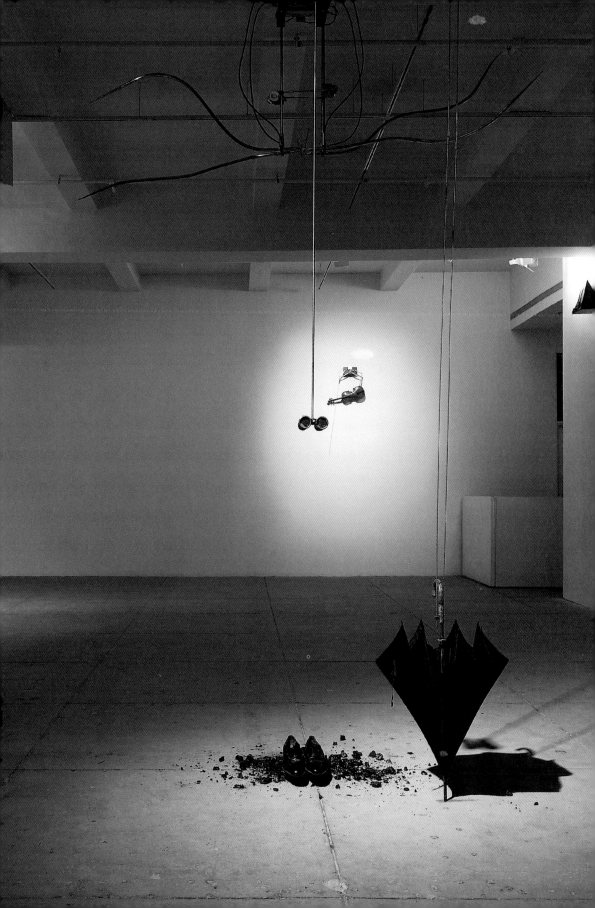

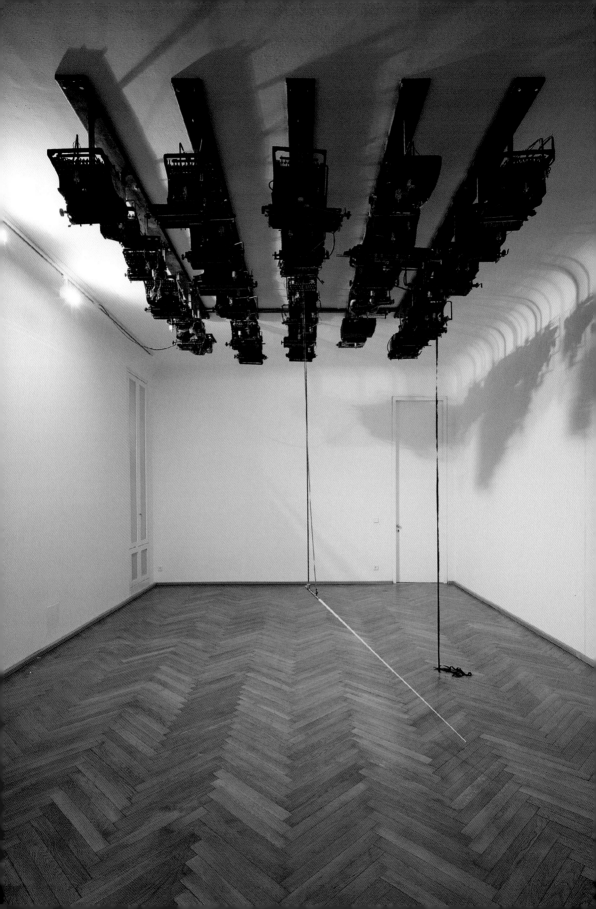

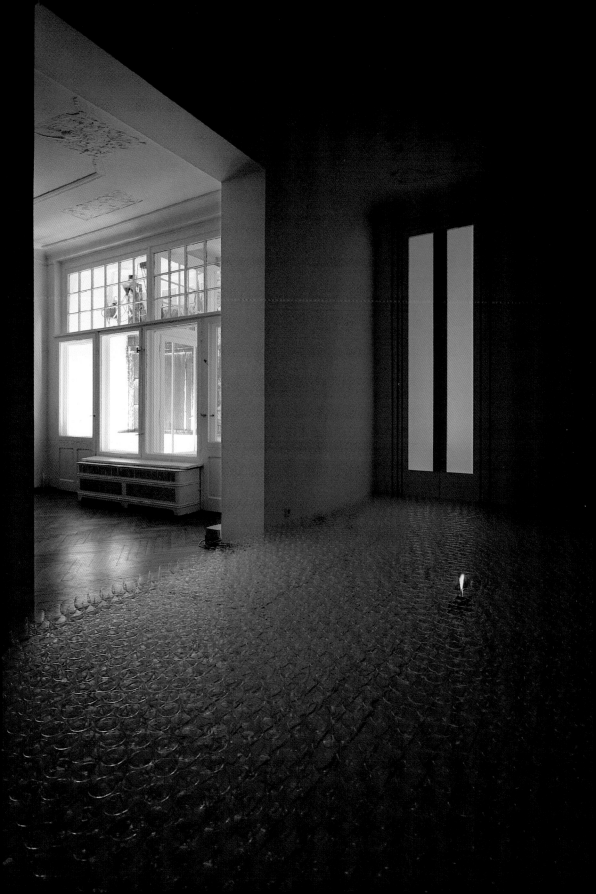

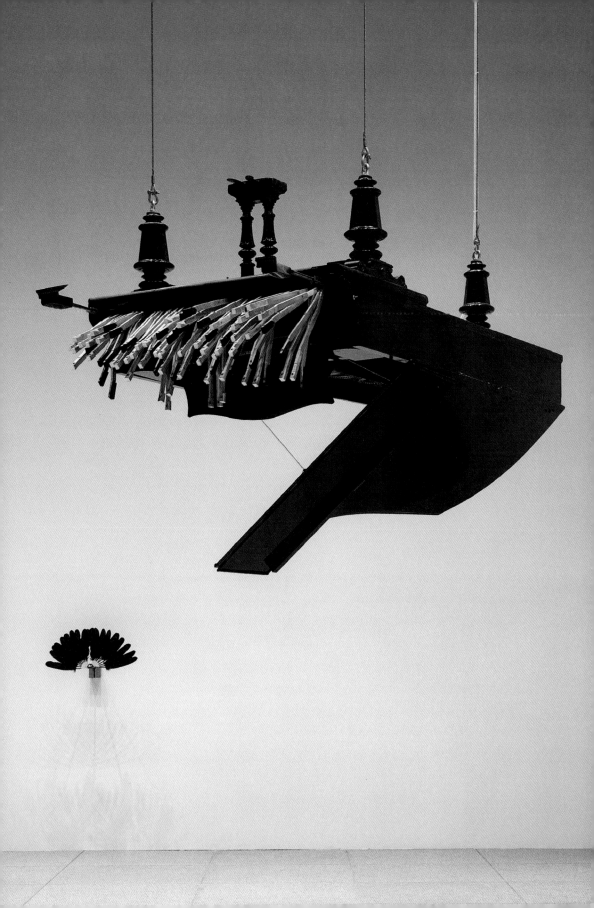

Revolt as a starting point

The Salpêtrière is a notorious hospital in Paris. 19th-century reports describing how the neurologist Jean Martin Charcot kept his patients here trussed in straitjackets, held examinations of the so-called 'hysterical curve', and performed experimental treatment using 'abreaction' and hypnosis have all contributed to the terror this institution inspires. In the spacious, domed Chapelle de Saint-Louis de la Salpêtrière Rebecca Horn in 1995 constructed a piece titled *Inferno,* a tower assembled from hospital beds that, criss-crossed and headdown, are hooked together into a spiral eddying up into the dome. From the uppermost bedframe beneath the ceiling water drips all the way down into a large black tray on the floor. This receptacle has the same dimensions as the bed, reflecting the tower and fracturing its mirror image. A pair of twitching copper snakes disturb the even ripples made when the drops of water hit the surface, fully dissolving the reflected image. The mounting spiral of bedframes is scanned by lightening rods that send hissing flames upwards. Here once more we have an example of how movement or light becomes a sculptural element. The rhythmically falling drops and the rising flashes of light appear to function as a kind of space and time lapse. Like a brace, they hold together the vortex of bedframes, setting up a cycle between above and below, both anchoring the intricate ceiling ensemble to the sky and rooting it in the ground. The flickering light and the dripping water are absurdly echoed in a small tuft of feathers seen nervously trembling over a child's cast-iron bedstead. This piece is dedicated to the English actor David Warrilow, who died of Aids during the early stages of the work's development. The feather plume is reflected in a pool of mercury which was poured into the base of the bedframe. On closer inspection you encounter your own portrait in the mercury mirror. You might then be given a further jolt on realizing that the spindly legs of the bed are balanced on four goose eggs and when you catch sight of your own mirror image concurring with the

On the previous pages: Berlin Earthbound, Berlin, 1994 (p. 84); Concert for Anarchy, Berlin, 1994 (p. 85)
Chorus of the Locusts 1, Berlin, 1991 (p. 82); Chorus of the Locusts 2, Berlin, 1991 (p. 83)
The Emigrant, Kafka's America, New York, 1990 (p. 80); Kafka's America, New York, 1990 (p. 81)

Tower of the Nameless, Vienna, 1994

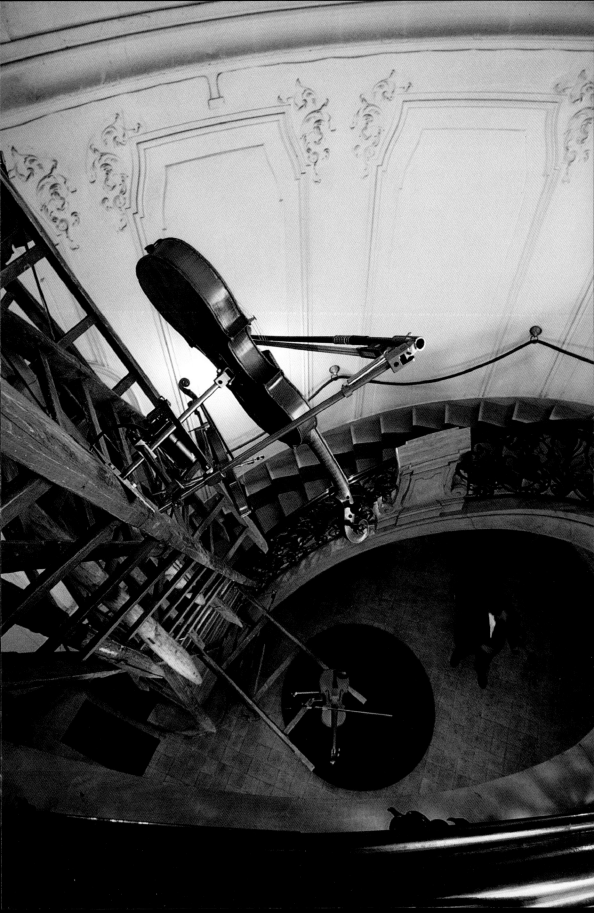

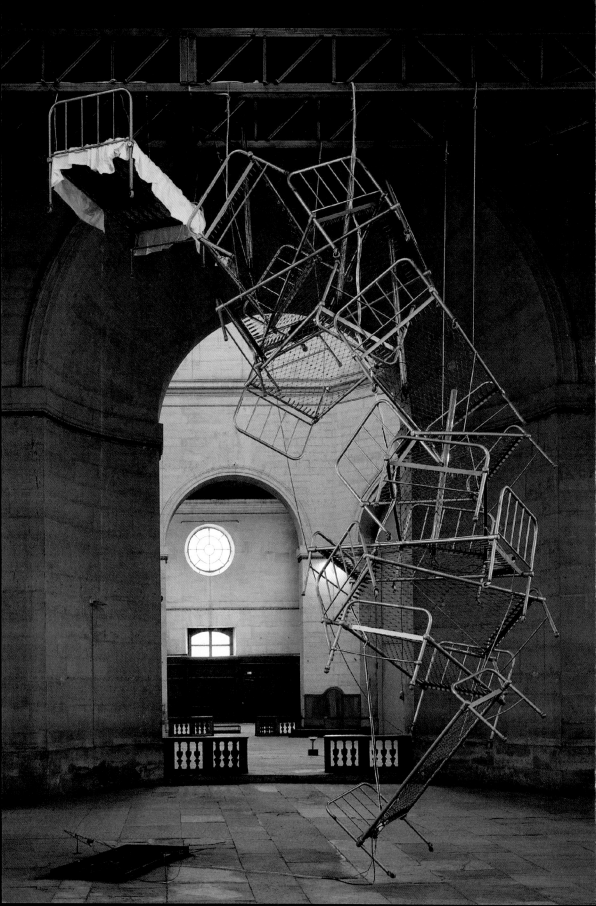

framed photograph of Warrilow attached to the bed. Yet the hesitant, feather-light pendulum blends in with the serial images of metronomes and conductor's batons, which in spite of all their apparent fragility probably represent no lesser incitement to revolt than does the crashing stone in the Schloss Ettersburg installation.

There is a close link between *Inferno* and *Tower of the Nameless,* which Rebecca Horn created in 1994 in the stairwell of an old villa located on the Naschmarkt in Vienna. There a whole concert of drawn-out, melancholic notes is played by numerous violins mounted on several tall, old fruit-picking ladders which are delicately slotted into each other to make up a dancing tower. The first ladder barely touches the floor, while the uppermost sections appear to twist so high up into the stairwell, almost as if they were trying to propel the entire chain of spiralling rungs out through the roof — as though the structure's centre had been displaced from bottom to top. Even the movements of the violin bows and their bowed notes seem to be working their way upwards. Suspended below the ceiling is a funnel from which black water drips down into a circular black basin of similar size eight metres below. The water drops are released once a second, and one has a sense that this falling movement provides a counterweight lending stability to the entire tower. In the black basin ripples calmly radiate out in an even pattern which is then intermittently disturbed by a pair of twitching copper snakes. Yet, as in all her works, the dripping water also beats the rhythm of the over-all room composition like an orchestrating metronome. In *Tower of the Nameless* the drops do in fact provide rhythmical accompaniment to a kind of lamenting concert music.

This work came about at the time of the first military upheavals in Yugoslavia. In the west, near the borders of Balkans, Rebecca Horn took notes of dramatic daily occurrences that were not to be found in any newspaper reports: 'Below ground Vienna was populated with refugees from the war in Yugoslavia, who were hiding out in doorways and subway tunnels. But everywhere one sensed the energy of music. Somehow these people had to express themselves — no longer could they make themselves understood with screams or words, all they had was music. This was their only way

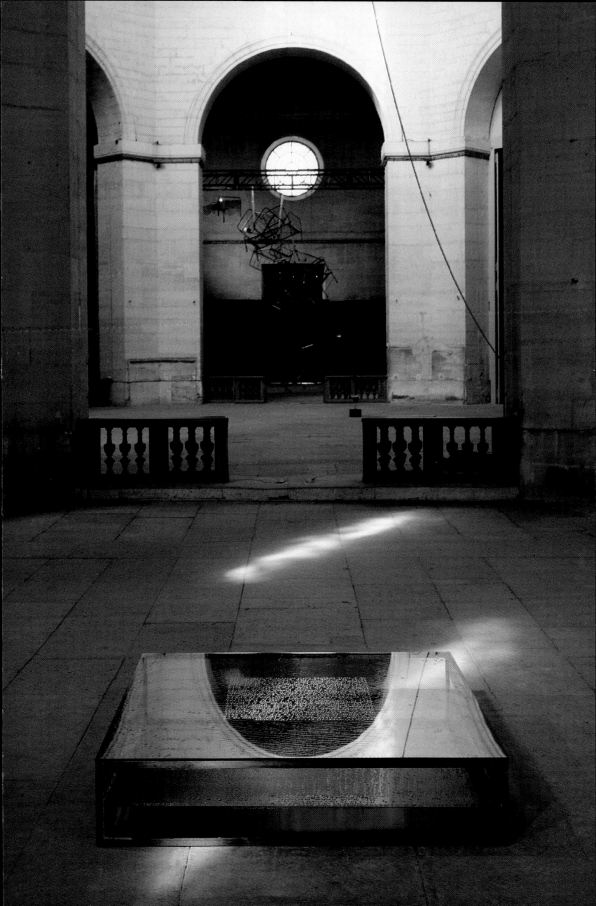

of articulating pain, since they spoke no German. They had no passports, no identity, they were fleeing. During the Third Reich, even before its takeover by Hitler, Vienna had already been a sort of transit station, and suddenly this dimension of escape had returned. I wanted to set some form of stability against this movement of flight, a place where these nameless people could rediscover their identity. So I constructed the tower of violins there, near the flea market. Every day a Yugoslav Gypsy came by and with his own violin playing transformed the music made by the mechanical violins, thereby turning the surrounding disharmony into new harmony.'[31]

In their concerted presence the violins exert sculptural power that would otherwise only be implied as an individual element. Similar to the visualization of powerful flows of energy capable of spreading out over entire continents, the violins formulate the acoustic dimension of these rivers or winds.

Whereas in *Tower of the Nameless* these currents fill out the room as a speechless lamenting choir, another of her sculptures catches and collects the voices and words of these currents, letting them flow through tubes: *The Turtle Sighing Tree,* first shown in New York in 1996, stands trembling on four squat legs. From out of its armoured casing numerous curved copper tubes sprout upwards, fanning out like the branches of a tree. At their ends the tubes blossom out into funnels from which whispering voices emerge. The voices plaintively utter laments; sighing, weeping and murmering, they speak in different languages of their grief. The viewer becomes a listener: when someone approaches the funnels to listen closely, he becomes a part of the sculpture. As the head disappears half way up the funnel, or the calyx, the figure of the listener appears to have become a bee or fruit on the tree. In the mind's eye of the visitor, however, the stream of voices might foster images that are not overtly visible, relating to the ineluctability of Goyaesque nightmarish visions. 'And every person', claimed Paul Valéry in his description of this inescapable terror, 'drags along behind him a chain of monsters which has inextricably grown from his actions and from the successive forms of his body'.[32] And curiously enough, the visitors' postures seem to converge — here, on the one hand, we find the listeners directing their ears from

Warlock's Memorial (left), The Blue Bath (Die chymische Hochzeit) (right), Chapelle Saint-Louis de la Salpêtrière, Paris, 1995

the outside towards the interior, while in the composition *Les Délices des Evêques,* on the other hand, there are observers peering through the crack, opening doors, becoming accessories to the deed.

The perpetuum mobile Rebecca Horn repeatedly depicts in her work not only raises the issue of the destructive and destroyed force of human existence, but also as a counterpoint focuses on the suffering, the quest and the unrelenting energy to start all over again. At the outset of the 20th century, at almost the same time as the manifestos of the international avant-garde were trumpeting their fanfares for 'universal culture', Aby Warburg jotted down a revolutionary idea on one of his notorious index cards: 'Humanity's holdings in suffering become the possessions of the humane'.[33] On the one hand he thereby transforms the key experience of Judaic culture of being bound up in 'world pain' *(Weltqual)* into an existential experience of universal character. At the same time, however, with his theory of the 'holdings in suffering' he also attempts to make out a residing energy in all human suffering, a force that should be transformed, brought to life, reassessed and reflected. Hence he views the figure of Laocoon as a universal idiom for suffering that possesses the power to 'create individuality and awareness'. Maybe Rebecca Horn's work can also be viewed in terms of such idioms, as pictorial figures that with replenished energy constantly come forth from destruction only to return to the beginning. On encountering streams of lamentation snaking their way out of the debris of Venice's ruins during the 1997 Biennale, it is difficult to determine whether the copper tubes and funnels themselves caused the stonework to rupture or if they burrowed through masses of rubble that were already there. Whichever view one takes, this could be conceived as a depiction of the converse side of revolt: here the dramatic laments of the individual voices are transformed into revolutionary energy. Can one be so sure that the mourners or the listeners might not one day pick up a stone and hurl it, or build a barricade?

Besides focal symbols that can occur individually, almost like archetypal pictograms, or that link up to form a composition, Rebecca Horn also creates images that recurrently unfurl and branch out, reminiscent of maps or satellite photographs. Like forms of materialized energy, they seem less to

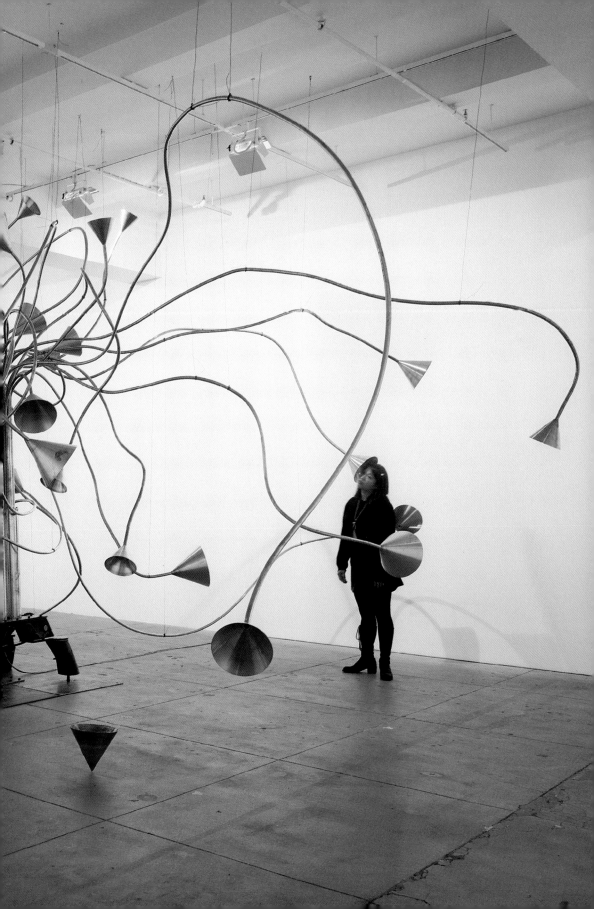

embody parts of the world than to traverse the entire world, like winds or ocean currents.

But even among theses expansive images there are some that occur individually as separate objects, while others combine to perform in large concerts. Created in 1982 in Sydney, *Spiral Bath* is a square glass container. Lying inside it on a reflective surface is a large egg. Attached by a thin piece of twisted wire to a ruler running diagonally through the glass case is a pair of scissors. Swinging to and fro, the scissors come within one hazardous millimetre of the egg. The egg itself is snow-white, while the glass case is speckled with black ink as though it had been caught in a shower of mourning. On the surface of the case the ink spreads out into a big swirl. Accompanying this work is a text by Rebecca Horn: 'In the southern hemisphere of our planet / there exists a fairly common species of migratory birds / which propagate so quickly / that only a ruse of nature / safeguards us from a horrendous nightmare / Each year they darken the heavens above West Africa / where they gather for their passage / across the Atlantic ocean / Only one-tenth of them reach South America / ninety percent falling dead from exhaustion into the middle of the sea / at the point where scientists assume / that millions of years ago / the great land mass broke apart / into two entirely separate continents / The birds began to circle frantically / seeking their land there / where it no longer exists / their instinct preserved over millions of years / guiding them to their exhausted death / Only the most insensitive reach the nether shore.'[34] So what kind of nightmare might be enclosed inside this snow-white egg? Or is it the other way round, is this inalienable interior, is the 'secret egg' protected from the encircling swarms of 'common migratory birds' precisely by the swaying scissors? This sets off a gyrating spiral of questions, and maybe it is important simply to respect the alienness of this sculpture, to defer to the otherness of this artistic sign, rather than trying to 'colonize' it.[35] Indeed, maybe it would occasionally be better to relinquish a little of our bourgeois compulsion to exert a cultural grasp on alien phenomena and to thereby take possession of them — maybe it would occasionally be preferable to experience the meaning of fear.

The Turtle Sighing Tree, New York, 1994 Concerto dei Sospiri, Biennale di Venezia, Venice, 1997

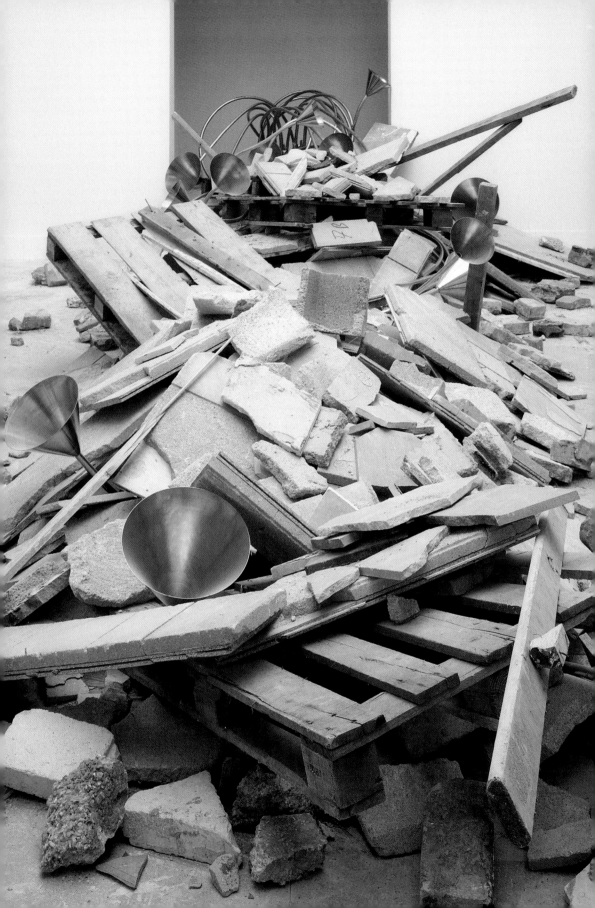

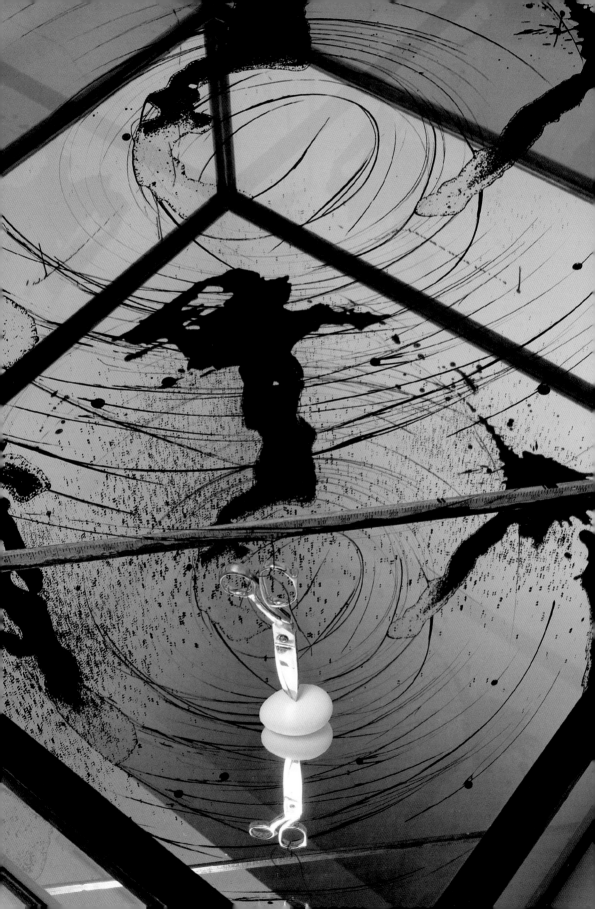

Yet it is also conceivable that with the egg — a pictorial object that from all interpretative variants one would no doubt primarily associate with the concept of beginning — the field of investigation surrounding 'revolt as volte-face' shifts into yet another dimension. For, as a quest for the centre, revolt only really makes sense if this centre itself then becomes the starting point for an opening towards a new purpose, the starting point for a form of self-investment. At this this juncture it is worth returning to Buber: 'All theory of contemplation is based on the gigantic delusion of the human spirit reversing back in on itself, that it takes place within the human subject. In fact the spirit emanates from the human subject — occurring between the subject and that what it is not. When the reversed spirit relinquishes this, its own meaning, the meaning of being related to something, it is compelled to draw into the human subject that which is not the human subject, it is compelled to spiritualize the world and God. This is the spiritual delusion of the human mind.'[36]

Rebecca Horn's pictorial idioms prevent the tranquil musings of contemplation, demanding instead a high degree of mental alertness. The radically formulated point zero in her works, the interminable tappings and bangings and the whipping up of space and time all show an artist who is driven by an acute presence of mind and the need to invent her own images. At the close of 1998 Rebecca Horn translated the reality of being an artist into an almost unbearable cipher. Mounted on a sequence of unframed white canvases hanging in a small room[37] were small, animal-like machines with two legs. With their bodies clinging to the edges of the frames, their tiny tentacular legs intermittently start drumming loudly. The canvases are splattered with caput mortuum, the colour of congealed blood — as if here that mysterious fluid were being used as paint. The work is called *Les Taupes de l'Art* (The Moles of Art). It is yet a further example of how much the upward movement of spirals, the astronomical charts, the flightpaths of birds or bees are, as a directly physical experience, constantly subject to an opposite pull. They are anchored in the parallel lines of underground passages, in that labour of burrowing that refuses to let grass to grow over things. From this vantage point it is evident that her pictorial idioms — snakes, bolts of lightening,

mirrors, water baths, mercury streams, tiny hammers, waterdrops, specks of pigment, styluses, compasses, handguns, funnels, stones, butterflies, metronomes, violins, conductors' batons, suitcases, shoes, coal, torches, flames, knives, canvases, glasses, typewriters, pencils, brushes, winds, waves, feathers, ladders, beds, grasshoppers, bees and moles — all belong to an immense and forever swelling stream that continues its uninterrupted path in a powerful spiral. However, this expansive vocabulary, these idioms that Rebecca Horn keeps on inventing, finding, changing, reviving and varying, these cyphers she incites to 'revolt' for a new beginning, this convolution of signs with which she understands how to address the viewer, are all related to a far lesser degree to some notion of art history, than to what Buber described as a 'Weltkonkretum', as the world as concrete object. And maybe it is this moment of feeling personally addressed and experiencing one's own responsibility that represents the true political moment in this work.

Translation: Matthew Partridge

1 Emmanuel Lévinas, *Quatre Lectures Talmudiques* (Paris, 1968): 'Je peux être responsable pour ce que je n'ai pas commis et assumer une misère qui n'est pas la mienne.'

2 Cf. Giorgio Agamben, *Quel che resta di Auschwitz* (Rome, 1998); *Ce qui reste d'Auschwitz* (Paris, 1999), pp. 34–40

3 A concept coined by Hannah Arendt in an interview with Günther Gaus, quoted in Agamben, loc. cit., p. 89

4 Rebecca Horn, in a poem written on the wall.

5 Julia Kristeva, *L'avenir d'une révolte* (Paris, 1998), p. 12

6 Saul Friedländer, *Quand vient le souvenir* (Paris, 1968), pp. 158ff.: 'Elle (l'incertitude) a toujours représenté notre manière d'être au monde et, à bien des égards, elle a, pour le meilleur ou le pire, fait de nous ce que nous sommes. Parfois, quand je pense à notre histoire, non pas celle de ces dernières années, mais à son cours tout entier, je vois se dessiner un perpétuel va-et-vient, une recherche de l'enracinement, de la normalisation et de la sécurité, toujours remise en cause, à travers les siècles, et je me dis que l'État juif aussi n'est peut-être qu'une étape sur la voie d'un peuple venu à symboliser, en sa particulière destinée, la quête incessante, toujours hésitante et toujours recommencée, de toute l'humanité.'

7 Martin Buber, *Die Legende des Baalschem,* (Zurich, 1955), p. 115

8 Paul Celan, *Gedichte,* Vol. 1 (Frankfurt / M., 1975), p. 157, 'Unten': 'Heimgeführt Silbe um Silbe, verteilt / auf die tagblinden Würfel (…)'

9 Edmond Jabès, *Le Livre des Questions* (Paris, 1963), p. 36: 'I am in the book. The book is my universe, my country, my roof and my enigma. The book is my breath and my peace of mind.'

10 Martin Buber, loc. cit., p. 8

[11] Paul Celan, loc. cit., p. 157

[12] Edmond Jabès, loc. cit., p. 320: 'Dans un village d'Europe centrale, les nazis – un soir, enterrèrent vivants quelques-uns de nos frères. Le sol, avec eux, remus longuement.' [...]

[13] Henri Bergson, *Materie und Gedächtnis* (Hamburg, 1991), p. 144

[14] George Steiner, *In Bluebeard's Castle. Some notes towards a re-definition of culture* (London, 1971), p. 13

[15] Rebecca Horn, unpublished notes

[16] Aby Warburg, *Mnemosyne,* Introduction, p. 1, quoted in: E. H. Gombrich, *Aby Warburg, An Intellectual Biography* (London, 1986), p. 288

[17] Rebecca Horn in an unpublished conversation with the author in January 1993

[18] All of Rebecca Horn's terms have been drawn from an unpublished conversation with the author in July 1997

[19] Hermann Broch, *Der Tod des Vergil* (Frankfurt/M., 1976), p. 315: '[...] dem leeren Nichts, das plötzlich aufklafft, das Nichts, für das alles zu spät und alles zu früh kommt, der leere Nichts-Abgrund unter der Zeit und unter den Zeiten, den die Zeit ängstlich und haardünn, Augenblick für Augenblick aneinanderreihend, zu überbrücken trachtet, auf daß er, der steinern-versteinernde Abgrund, nicht sichtbar werde.'

[20] *Duro es el paso* (Hard is the way), *Desastres de la guerra,* 14, 1810–11, quoted in: Werner Hofmann, *Goya, Traum, Wahnsinn, Vernunft* (Hamburg, 1981), p. 108

[21] *Que se rompe la cuerda!* (May the rope break!), *Des.* 77, 1815–20, ibid. p. 94

[22] Jürgen Habermas, *Geschichte ist ein Teil von uns* (History is part of us), Laudatio for Daniel Goldhagen in: *Die Zeit,* No. 12, 1997, p. 14

[23] Rebecca Horn, *The Sicilian Palast Journey,* in the catalogue *The Glance of Infinity* (Zurich/Berlin/New York, 1997), p. 112

[24] ibid., p. 122

[25] Rebecca Horn in a conversation with the author, April 1999

[26] *The Glance of Infinity,* p. 121

[27] Martin Buber, *Das Dialogische Prinzip* (Heidelberg, 1984), p. 153

[28] Ibid.

[29] Ibid., p. 154

[30] Ibid., p. 157: 'das Weltkonkretum'

[31] Rebecca Horn, *Cutting through the Past*

[32] Paul Valéry, *Eupalinos:* '... et chaque homme traîne après soi un enchaînement de monstres qui est fait inextricablement de ses actes et des formes successives de son corps.'

[33] Aby Warburg, *Handelskammer,* Notebook, 1928, p. 6, quoted in E. H. Gombrich, loc. cit., p. 250, footnote 1: 'Der Leidschatz der Menschheit wird humaner Besitz.'

[34] Rebecca Horn, text, 1979, *The Glance of Infinity,* loc. cit., p. 242

[35] David Freedberg, *The Power of Images* (Chicago–London, 1989), p. 426: 'If schematically, we assume that ordinary people happen to conflate, while elite segments deliberately strive to avoid compulsion of referentiality, what are we to make of the ways in which we find ourselves attempting to make sense of the picture by reconstituting that which is or which we want to be within it? It is only in late bourgeois society that we do so, that we feel compelled to make sense of nature in terms that we can visually recognize, that we colonize alien nature by incorporating it directly into art on which we thrive?'

[36] Martin Buber, loc. cit., p. 95

[37] Galerie de France, Paris

With special thanks to
the technicians of the Weimar installations:
Peter Weyrich, Harald Müller,
Philipp Haas, Alexander Reichert,
Werner Weichel, Helge Müller

Rebecca Horn

Rebecca Horn – Concert for Buchenwald

English translations: Matthew Partridge
Design: Hans Werner Holzwarth, Berlin
Photographers: Attilio Maranzano, pages 10 – 60, 70, 84 –104;
John Abbott, Michael Summers, Werner Zellien
Lithography: Gert Schwab / Steidl, Schwab Scantechnik, Göttingen
Printed by Th. Schäfer, Hanover
© 2000 for the reproductions: Rebecca Horn
© 2000 for the texts: the authors
© 2000 for this edition: Scalo Zurich – Berlin – New York
Head office: Weinbergstrasse 22a, CH-8001 Zürich / Switzerland,
phone 41 1 261 0910, Fax 41 1 261 9262,
e-mail publishers @ scalo.com, website www.scalo.com
Distributed in North America by D. A. P., New York City;
in Europe, Africa and Asia by Thames and Hudson, London;
in Germany, Austria and Switzerland by Scalo.

First Scalo Edition 2000
ISBN 3-908247-22-5
Printed in Germany

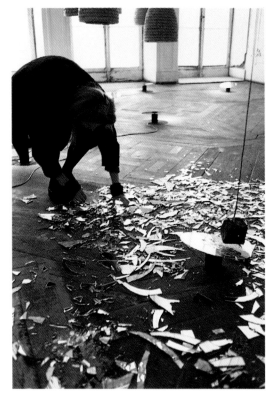

Rebecca Horn, Weimar, 1999